Mary Reynolds

and the Spirit of Surrealism

THE ART INSTITUTE OF CHICAGO *Museum Studies*

THE ART INSTITUTE OF CHICAGO *Museum Studies*

VOLUME 22, NO. 2

ISSN 0069–3235

ISBN 0–86559–135–0

Published by The Art Institute of Chicago, 111 South Michigan Avenue, Chicago, Illinois 60603-6110. Regular subscription rates: $20 for members of the Art Institute, $25 for other individuals, and $32 for institutions. Subscribers outside the U.S.A. should add $10 per year.

For individuals, single copies are $15.00 each. For institutions, all single copies are $19.00 each. For orders of single copies outside the U.S.A., please add $5.00 per copy. Back issues are available from The Art Institute of Chicago Museum Shop or from the Publications Department of the Art Institute at the address above.

Executive Director of Publications: Susan F. Rossen; Guest Editor: Terry Ann R. Neff; Editor of *Museum Studies*: Michael Sittenfeld; Designer: Ann M. Wassmann; Production: Daniel Frank and Sarah Guernsey; Subscription and Circulation Manager: Bryan D. Miller.

Unless otherwise indicated in the captions, all photographs in this issue were produced by the Department of Imaging and Technical Services, Alan Newman, Executive Director.

Volume 22, no. 2, was typeset in Stempel Garamond by Z...Art & Graphics, Chicago; and 10,000 copies were printed by Hull Printing Co., Inc., Meriden, Connecticut.

Front cover: photograph of Mary Reynolds by Man Ray, 1930; inset: bookplate designed by Marcel Duchamp for the Mary Reynolds Collection.

Back cover, top to bottom: *Dada* 6 (*Bulletin Dada*), cover (see p. 141, fig. 10); Hans Bellmer, *La Poupée (The Doll)*, detail (see p. 155, fig. 5); Leonora Carrington painting the mural *El Mundo Mágico de los Mayas* (see p. 179, fig. 12); Berenice Abbott, *Edward Hopper*, detail (see fig. on p. 180).

This volume was supported in part by a grant for scholarly catalogues and publications from The Andrew W. Mellon Foundation.

The Art Institute of Chicago thanks Marjorie Hubachek Watkins for her financial support of this issue of Museum Studies.

Table of Contents

THE ART INSTITUTE OF CHICAGO

Museum Studies, Volume 22, No. 2
Mary Reynolds and the Spirit of Surrealism

Foreword

It is a truism that Chicago collectors have long had a passion for Surrealism. Although this was evident in The Art Institute of Chicago's galleries of twentieth-century painting and sculpture, it was only with the reinstallation in 1993 of the museum's holdings of art from 1900 to 1950 that the breadth and range of Chicago's interest in the movement became clear. It was now possible to enrich the paintings and sculptures with items in other media, media that are often called minor or considered ephemeral but that, in many ways, were central to the enterprise of the Surrealists: found objects, collaged objects, printed books, posters, manifestos, postcards, and the like. In the course of considering the resources available to tell this tale, Charles Stuckey, then Curator of Twentieth-Century Paintings and Sculpture, and Susan Godlewski, then Associate Director of Ryerson and Burnham Libraries, determined to devote a gallery to these manifestations of the Surrealist spirit in many media. The response to this display has been very strong—the books, bookbindings, photographs, and objects shown on a rotating basis have a force and an immediacy that illuminate the world of Surrealism in a direct and enticing way.

The items cared for by the Art Institute's libraries that are now shown in Gallery 245 have been in the museum for years, but, like many fragile objects, have been stored and not displayed. They have been available to those who knew of their existence, and have been documented in a catalogue now out of print (Hugh Edwards, ed., *Surrealism and Its Affinities: The Mary Reynolds Collection* [Chicago, 1956; 2nd ed., 1973]). Thus, we are grateful not only to be able to show selections in the galleries but also to present some of them in context and in depth in this issue of *Museum Studies*.

The library's Surrealist holdings are chiefly in the Mary Reynolds Collection, presented to the Art Institute in 1951 by her brother, Trustee Frank B. Hubachek. Marcel Duchamp, who had shared his life with Reynolds for a quarter of a century, strongly supported the idea of the gift and designed a bookplate for the collection (see illustration on this page). Mary Reynolds, as Susan Godlewski demonstrates in her empathetic essay, was, in her quiet way, a central figure in the Surrealist milieu and an artist of wit and distinction in her own chosen medium of bookbinding, a "minor art" that enjoyed a major vogue in the 1920s and 1930s. Her fascinating personal and artistic life, previously recorded only in snippets and brief references in the diaries and memoirs of her contemporaries, reveals a woman who was an active participant in the major cultural centers of New York and Paris and who also served as a member of the French Resistance in the heart of Nazi-occupied Paris long after others had fled. It is a pleasure to give Mary Reynolds her full place in the roster of the Surrealists and to acknowledge the years of study and research that enabled Susan Godlewski to accomplish this.

Surrealism was not really about fine art, but aimed to become an all-encompassing attitude that could affect, if not a mass audience, at least other artists, through literary means such as posters, manifestos, poetry, literature, and magazines. Irene Hofmann, who has organized the personal letters, records, and documents in the Mary Reynolds Archive and worked extensively with the collection itself in mounting exhibitions in Gallery 245, writes in her essay of the complex geographic and intellectual history of the chief journals produced by Dada and Surrealist artists in Germany, France, and the United States from 1920 to the late 1940s. That the Art Institute has copies of all of the titles she discusses is thanks to the Mary Reynolds Collection; Reynolds herself served as the Paris representative for *View*, one of the American Surrealist titles, when she returned to her beloved France after the war.

In *Minotaure*, one of the periodicals Hofmann discusses, appears the work of Hans Bellmer, a German artist whose own monographic—one is tempted to say mono-maniacal—publications focusing on the female body in photographs of dolls and artists' lay-figures are strongly represented in the Reynolds Collection and in other Art

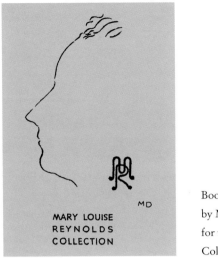

Bookplate designed
by Marcel Duchamp
for the Mary Reynolds
Collection.

Institute holdings. Sue Taylor, who is completing her dissertation in the Department of Art History at the University of Chicago, places Bellmer and his art firmly in their artistic and psychoanalytic contexts, illuminating our understanding and perhaps reminding us that art is not concerned solely with the beautiful, but also with all aspects of the human psyche, a subject of prime interest for the Surrealists.

Always international in outlook, the Surrealist movement and its members were dispersed by the events of World War II to the four corners of the earth; when Mary Reynolds left Paris in 1942, nearly all her circle had preceded her. Many came to the new world, chiefly New York, California, and Mexico. The English artist Leonora Carrington, whose life holds many parallels with that of Mary Reynolds, was part of the Paris circle of Surrealists in the late 1930s. She escaped in the early 1940s to Mexico, where she has spent nearly all the intervening years. Her portrait *Juan Soriano de Lacandón*, discussed in light of her early Surrealist interests and long-time exposure to Mexican myth and iconography by Clare Kunny, senior lecturer in the Art Institute's Department of Museum Education, shows the mutability and durability of the Surrealist point of view.

Finally, Gail Levin, Professor of Art History at Baruch College and The City University of New York, the leading scholar on the American artist Edward Hopper,

places one of his (and the Art Institute's) most famous paintings, *Nighthawks*, in its time, an era of war and uncertainty even for those not displaced from their chosen homes, as were Reynolds, Duchamp, Carrington, Max Ernst, and so many others. Levin also explicates and documents Hopper's awareness of and interest in Surrealist art, adding to our understanding of the complexity of this very American artist.

I am grateful to the authors for their thoughtful work with this rich collection; to Michael Sittenfeld, editor of *Museum Studies*, for his interest and support in preparing this issue; to Terry Ann R. Neff, for her astute reading and editing of the articles; to Ann Wassmann, whose sensitive design of this issue captures the spirit of Mary Reynolds's own book works; to Daniel Frank and Sarah Guernsey, who worked long and hard on the production of this issue; to Barbara Korbel, Conservation Librarian, and her staff for their excellent craft in preparing the frequently problematic objects for display and photography; to Anne Champagne, Head of Technical Services in the Ryerson and Burnham Libraries, who supervised the cataloguing of the collection for the on-line catalogue; and to Daniel Schulman, Assistant Curator of Twentieth-Century Painting and Sculpture, for his insightful reading of the manuscripts. But I am most deeply grateful to Marjorie Hubachek Watkins, Mary Reynolds's niece. Her memories of "Aunt Mary" in Chicago, at her family's camp in Minnesota, and in France; her gift of additional letters, photographs, and family papers and memorabilia to document Mary Reynolds's life and the gift of her collection to the Art Institute by Frank B. Hubachek; and her financial support and sustained interest over time have enabled us to give this Surrealist sampler to you in all its richness.

Selections from the nearly five hundred pieces in the Reynolds Collection are on view in the galleries on a rotating basis; most are available for viewing or scholarly use by appointment in the Art Institute's Ryerson and Burnham Libraries, where they form a lasting tribute to Mary Reynolds's gentle, Surrealist spirit.

JACK PERRY BROWN
Director, Ryerson and Burnham Libraries

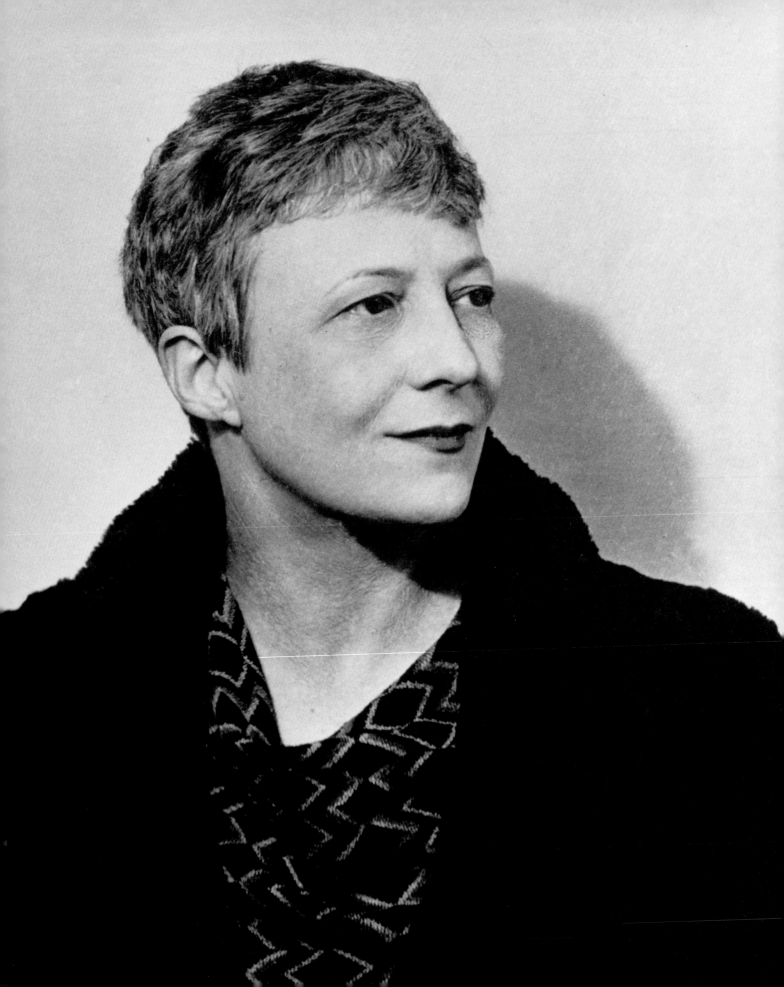

Warm Ashes: The Life and Career of Mary Reynolds

SUSAN GLOVER GODLEWSKI

Boston, Massachusetts

By nature a modest, self-effacing woman who preferred being in the background, Mary Reynolds nonetheless found herself at the center of the Surrealist movement, as both artist and advocate. As the artist Marcel Duchamp described her, she "was an eye-witness of the Dadaist manifestations and the birth of Surrealism in 1924. . . . [and] was among the 'supporters' of the new ideas. In a close friendship with André Breton, Raymond Queneau, Jean Cocteau, Djuna Barnes, James Joyce, Alexander Calder, [Joan] Miró, Jacques Villon and many other important figures of the epoch, she found the incentive to become an artist herself. She decided to apply her talents to the art of bookbinding."[1] The bindings preserved in the Mary Reynolds Collection at The Art Institute of Chicago are an eloquent testament to her significance as an artist.

Duchamp was a key influence on Mary Reynolds's life and art. For nearly three decades, Reynolds and Duchamp enjoyed a union that was "thought by their friends to be happier than most marriages."[2] From the late 1920s on, Duchamp had two addresses in Paris: his own small apartment on rue Larrey and Reynolds's house on rue Hallé. He had long before stopped making art publicly, but continued to be immersed in the "new forms of rebellion" that would lead to Surrealism. Reynolds joined him in this activity, and it is the resulting Surrealist vocabulary, with its wit and surprise, that most informs her work.

Early Life: 1891–1921
Mary Louise Hubachek Reynolds was born in 1891 in Minneapolis into a well-to-do family; her father, Frank Rudolph Hubachek, was a lawyer; and her mother, Nellie Brookes Hubachek, a homemaker. Educated in Minneapolis public schools, Mary Hubachek went east in 1909 to attend Vassar College, from which she received her Bachelor of Arts degree in 1913. By all accounts, "Mary Hub," as her college friends referred to her, was "a lovely person . . . so gentle and . . . she had many friends among us."[3] After graduation, she moved back to Minneapolis, where she took postgraduate courses at the University of Minnesota. Her only sibling, Frank Brookes Hubachek, was also a student there at the time. They had been close since childhood. Brookes, as he was known, acknowledged this in 1963: "While it would doubtless be difficult for an observer to agree, Mary and I were cut from the same cloth."[4] Their mutual affection and respect only grew through the years.

FIGURE 1

Man Ray (Emmanuel Radnitzky) (American, 1890–1977). Photograph of Mary Reynolds, 1930. All photographs of Mary Reynolds reproduced in this article are in the Mary Reynolds Archive at The Art Institute of Chicago, unless otherwise noted.

Outwardly gentle, Mary Reynolds was a woman of strength, character, and determination. Her activities in the French Resistance illustrate this, as does the fact that she escaped from Nazi-occupied France without help from either her brother or her lover.

During this period, Mary Hubachek met Matthew Givens Reynolds, the son of a St. Louis judge. Not much is known about their courtship; however, it must have progressed swiftly from casual dating to a serious relationship. The two were married at her family's country home on July 24, 1916. The marriage was a happy one; they were perfectly suited to each other and very much in love. During their engagement, Matthew Reynolds had accepted a position with an English insurance company that specialized in ocean shipping, and he moved to New York. After the wedding, the couple settled in Greenwich Village, the center of Bohemian life in the United States at the time. Populated by artists, writers, designers, and nonconformists of all types, the Village was exciting, energetic, and a slightly dangerous place with much to amuse the young couple. This free and easy, spirited living appealed to Reynolds, who clearly was trying to break free of the orthodoxy of her upbringing and define herself. People and situations that some would have found shocking, Reynolds found exhilarating.

When the United States entered World War I, Matthew Reynolds enlisted. Commissioned in November 1917, he left for the front a mere sixteen months after his wedding day. Reynolds commanded a battery of field artillery with the famous 33rd Wildcat Division, which was instrumental in breaking through the Hindenburg line, a turning point in the war. Although he survived the horrors of trench warfare, Matthew Reynolds died of influenza on January 10, 1919. His widow was devastated. She stayed with a close friend from Vassar, Elizabeth Hilles, for a time after receiving the dreadful news. Hilles, who considered Mary Reynolds one of her "dearest and closest friends," remembered Reynolds "was struggling with the problem of the future, and I felt that she would never recover from her loss.

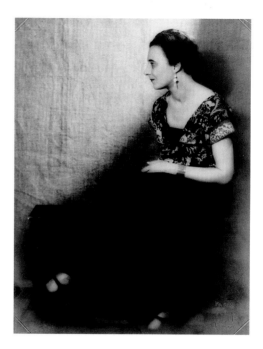

She said one day, 'Bess, you can fill your life with causes, but I can't. I've never cared for anything but people, and all my dreams were fulfilled in Matthew. Now my life is empty.'"[5]

Reynolds briefly returned home to Minneapolis, but it was not a happy visit.[6] Her parents were determined that she should get on with life, remarry, and begin a family. She was equally as determined to chart her own course. Matthew Reynolds had embodied all of her dreams. She could not simply move on so soon to a life without him. This falling out with her parents was serious and propelled her back to New York and shortly thereafter to Paris. As was true of many war fatalities, Matthew Reynolds's body was not sent home for burial. Consequently, his widow felt the need to travel to Europe, where he had spent his final year, to be close to his spirit. For Reynolds, this was a way of emancipating herself from the unbearable expectations of home as well as confronting her loss. The move was to be a pivotal change in her life. The writer Janet Flanner, Reynolds's intimate

BELOW FIGURE 2
Mary Reynolds, late 1910s or early 1920s.

ABOVE RIGHT FIGURE 3
Man Ray. Photograph of Mary Reynolds, c. 1925–35.

friend, noted that Reynolds became "part of the colony of about 5,000 Americans to whom Paris . . . seemed liberty itself."[7]

The Early Paris Years

In April 1921, Reynolds arrived in Paris, settling in Montparnasse, a community that reminded her of Greenwich Village. Duchamp reminisced that "Montparnasse was the first really international colony of artists we ever had. Because of its internationalism, it was superior to Montmartre, Greenwich Village, or Chelsea."[8] Reynolds quickly came to know many of its most interesting residents. She became a fixture on the party circuit, even introducing the artist Man Ray and the composer Virgil Thomson to each other in 1921, shortly after they had each arrived from New York.[9] When the American socialite Peggy Guggenheim, Reynolds's close friend, married novelist, poet, and painter Laurence Vail in 1922, the Paris avant-garde was stunned. Everyone had assumed that Reynolds and Vail were engaged to each other.[10]

It was probably as a result of her relationship with Vail that Reynolds gained access so quickly to the café society. Vail was known variously as the "King of Montparnasse" or the "King of Bohemia." The American literary critic Malcolm Cowley recalled: "Laurence was in the center of things. If you knew anyone, you knew Laurence."[11] Vail introduced Peggy Guggenheim to both Reynolds and the writer Djuna Barnes, another of his entourage. All three became close, lasting friends. Guggenheim described Reynolds and Barnes as being among the most outstanding beauties of Montparnasse: "They [each] had the kind of nose I had gone all the way to Cincinnati for in vain."[12]

Reynolds and Duchamp initially met in New York when both were living in Greenwich Village. They renewed their acquaintance in Paris in 1923, spending considerable time socializing at the Boeuf sur le Toit and other cafés while their involvement deepened. The relationship did not run smoothly, however, for Reynolds. Duchamp cherished his freedom and his unconventional, even shocking, life. He insisted that their relationship be kept secret. If they ran into each other in public, Reynolds was not to acknowledge him. Duchamp continued to see others and expected her to do the same (she did not). This created tremendous conflict for her that took its toll. Reynolds began to drink excessively.[13] She finally confirmed in 1924 to writer and critic Henri Pierre Roché, one of Duchamp's most intimate friends, that Duchamp was, indeed, her lover, but lamented his lack of fidelity and continued attraction to "very common women."[14] She suspected Duchamp was "incapable of loving" and unable to commit to one person. Some twenty

FIGURE 4
Man Ray. *Photograph of Mary Reynolds and Marcel Duchamp.* Gelatin silver print; 15 x 14.9 cm. The Art Institute of Chicago, Gift of Frank B. Hubachek (1970.796).

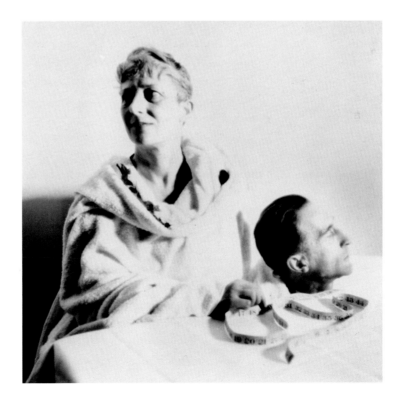

years later, the wife of the sculptor Antoine Pevsner spoke of meeting Reynolds when Peggy Guggenheim brought her unexpectedly to dinner. "We were amazed," recalled Virginia Pevsner, "to learn that Mary had been with Marcel Duchamp for nearly 20 years. During that time, Pevsner had seen Duchamp 2 or 3 times a week and Marcel had never said a word."[15] Beatrice Wood captured this part of Duchamp's character most closely when she stated, "Everybody loves him. He belongs to everybody and to nobody."[16]

Though Duchamp remained an enigma to most, he and Reynolds seem to have found their common ground after Duchamp's short-lived marriage to Lydie Sarazin-Levassor in 1927. Duchamp finally relented and allowed their relationship to become public. He later described it as "a true liaison, over many, many years, and very agreeable"; although he did qualify it by remarking that they "weren't glued together, in the 'married' sense of the word."[17] Although they never married, from 1928 until the Nazi occupation of Paris separated them, Reynolds and Duchamp were seen together, lived together, vacationed together. In her memoirs, Peggy Guggenheim wrote: "Every time Mary was asked why she didn't marry Marcel, she would say Marcel didn't want to. Every time Marcel was asked, he would say Mary didn't want to."[18] There was probably some truth in each statement. Reynolds wore her wedding band from her marriage to Matthew Reynolds her entire life. It appears that, in some way, Reynolds was just as unavailable to Duchamp as he was to her.

Mary Reynolds: "Reliure"
In the 1920s, women in search of a fashionable vocation in the arts turned increasingly to bookbinding. In 1929, Mary Reynolds followed this trend and trained in bookbinding in the atelier of acclaimed French book designer

Pierre Legrain.[19] With the patronage of prominent Paris couturier Jacques Doucet, Legrain had become one of France's most innovative and influential bookbinders of the early twentieth century. Although trained as a decorator and furniture designer, Legrain developed a new vocabulary of ornament in bookbinding that was decidedly fresh and contemporary. He introduced innovative materials that were lavish and exotic: precious gems and metals, skins such as lizard, python, and even crocodile and shark.[20] Legrain viewed the book cover as a continuous plane upon which to place his designs. He explored the possibilities of typographic form, placing varying fonts and letters in modernist juxtapositions. The influence of De Stijl, which was emerging in the Netherlands during the same time Legrain was developing his design tenets, can be seen in his nontraditional approach, simplification of compositional elements, and use of geometric devices. Prior to Legrain's sweeping modernization, French bookbinders had copied the ornate and elaborate bindings of the Louis XIV period, with its complex tracery and elegant materials. The modern style introduced to bookbinding by Legrain was rapidly and enthusiastically embraced by French connoisseurs and collectors and widely imitated by other bookbinders.

Jacques Doucet and Duchamp had been friends since the early 1920s. It is likely that it was through this connection that Reynolds became an apprentice in the most fashionable and busiest bookbindery in the city. Reynolds spent just one year in Legrain's atelier—long enough to learn the basics of book construction. Because Legrain was a designer, not a binder, artisans in his atelier realized his designs. Reynolds, therefore, would have studied the craft itself directly with binders in his employ; she learned the language of design, however, from Legrain himself. One sees this in her

nonconformist use of exotic materials and her manipulation of letterforms.

Over the next decade, Reynolds refined her skills, binding only for friends. Kathe Vail, the daughter of the writers Laurence Vail and Kay Boyle, remembered that "Mary Reynolds made a beautiful binding for [Laurence Vail's] 1931 novel *Murder! Murder!*"[21] Later, Henri Pierre Roché was so taken with a binding that she executed for his book *Don Juan* that he considered asking her to bind his son's personal illustrated diary.[22] It was during this period that Reynolds and Duchamp undertook their first recorded collaborative work. In 1935, they conceived and executed a binding for Alfred Jarry's *Ubu Roi* (see cat. no. 1). By January 1939, Reynolds felt comfortable enough with her work to list her occupation as "Bookbinder" on her business cards: MARY REYNOLDS / RELIURE / 14 R. HALLÉ, PARIS XIV.

Fortunately, Reynolds did not have to live on the income from her bookbinding business. Although often referred to as an "heiress," Reynolds, in fact, lived simply on the income from a modest trust established by her parents, and her pension as a war widow. Because she did not have to work, she could experiment and explore her chosen medium. Her involvement with Dada and Surrealism and passion for new ideas enabled her to develop a remarkable visual vocabulary. Duchamp described her bindings as being "marked by a decidedly Surrealistic approach and an unpredictable fantasy."[23] Reynolds's technique, however, did not always equal her artistic ideas—a matter of concern to Duchamp when he and Brookes Hubachek began considering what to do with her oeuvre after her death. The artist expressed to her brother the "hope that you will find a place where they will be kept together as artistic bindings although the 'specialists'

might object to the liberties Mary sometimes took with the technical achievement."[24] Reynolds focused on the design, regardless of whether the binding structures worked well. Her ingenuity was not bound by tradition. She followed in the manner of Legrain, considering the covers and spine of the binding to be a single, continuous plane upon which to work. Reynolds considered the design both two-dimensionally, as in the case of Raymond Queneau's *Odile* (cat. no. 8), as well as three-dimensionally, as is the case of Jarry's *Docteur Faustroll* (cat. no. 2).

Legrain felt that the binding should relate to the contents of the work it contained, that it should "evoke not the flower, but its fragrance."[25] Reynolds subscribed to that theory on most occasions, though frequently with a twist, as in the binding for Brisset's *La Science de Dieu* (cat. no. 7) or the Man Ray/Paul Eluard work, *Les Mains libres* (cat. no. 14). In other cases, such as Queneau's *Saint Glinglin* (cat. no. 6), it is very difficult to relate the design of the binding to the intellectual content of the book.

While Legrain's influence is important, Reynolds's ironic wit and Duchamp's artistic ideals and the resulting Surrealist vocabulary most define her work. The pun was one of Duchamp's favorite devices. Reynolds borrowed this tool from him with great success in a number of her extraordinary bindings. For instance, while creating the drawings used in *Les Mains libres*, Man Ray described his hands as "dreaming."[26] Reynolds created a physical pun by placing delicate kid gloves slit open and laid on the front and back covers of the binding. The cut-open gloves symbolically freed the hands and allowed them to

Reynolds's involvement with Dada and Surrealism and passion for new ideas enabled her to develop a remarkable visual vocabulary in her bookbindings.

dream. She employed the pun again for Jarry's *Le Surmâle* (cat. no. 12) with her use of a metal corset stay bursting out of a delicate butterfly. The application of boa-constrictor skin to create the fronds of a jungle plant on William Seabrook's *Secrets de la jungle* (cat. no. 10) juxtaposes the fear associated with the large jungle reptiles with the cool protection afforded by the jungle canopy. Reynolds suggested the danger of the jungle with her choice of materials.

It is difficult to assess fully the significance of Reynolds as an artist because of unresolved questions about Duchamp's role in the conception of these works. That he had a role is certain; the extent and import of his involvement is the issue. Some of the collaborative works of Reynolds and Duchamp, such as *Ubu Roi* and *Hebdomeros* (cat. nos. 1, 17), are well documented in the literature about Duchamp. Other projects clearly appear to be the result of their working together on the concept. The binding for *Docteur Faustroll*, for example, conceptually speaks Duchamp's language, specifically suggesting his *Fresh Widow* (1920; The Museum of Modern Art, New York). Duchamp, himself, always attributed the success of the bookbindings to Reynolds's wit and talent. On only a few occasions did he reveal his own contributions to the creative process. While he may not have had an active part in the design of all the Reynolds's bindings, one must assume his influence was at least subliminal.

The 1930s

The 1930s marked a period of tranquillity, contentment, and artistic achievement for Reynolds. Her relationship with Duchamp had settled into a comfortable intimacy. Her creativity and binding production were at their highest levels. She held an open house almost nightly at her home at 14, rue Hallé,

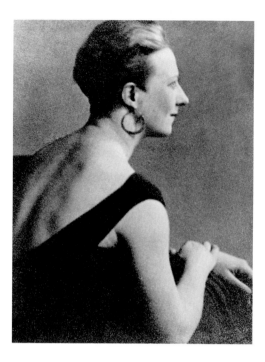

FIGURE 5

Man Ray. Photograph of Mary Reynolds, c. 1930s.

with her quiet garden the favored spot after dinner for the likes of Duchamp, Brancusi, Man Ray, Breton, Barnes, Guggenheim, Eluard, Mina Loy, James Joyce, Cocteau, Samuel Beckett, and others.

Ever protective of his independence, Duchamp always maintained a separate small studio. Even so, he spent most of his time at rue Hallé, and the interior of Reynolds's home was one of their most public collaborations. Man Ray described Duchamp as taking an interest in "fixing up the place, papering the walls of a room with maps and putting up curtains made of closely hung strings, all of which was carried out in his usual meticulous manner, without regard to the amount of work it involved."[27] Anaïs Nin recalled visiting "Marcel Duchamp and his American mistress. A studio full of portfolios, paintings, and her collection of earrings hanging on the white walls, earrings from all over the world, so lovely, every beauty of design duplicated by a twin, some of them twinkling, some cascades of delicate filigree, some heavy and carved."[28] Peggy

Guggenheim remembered lovely furniture, maps everywhere, a lighted globe of the earth.[29] One wall was painted a deep blue, with tacks placed at different angles connected with string. The comparison with Reynolds's garden must have been remarkable: an elegant, kinetic interior contrasting with a serene, cool exterior.

The War Years: Occupation and the French Resistance

This idyllic lifestyle was not to last, however. In Germany, the rise of Adolf Hitler and his National Socialist Party threatened the European continent. While Reynolds and Duchamp kept an eye on the approaching menace, the rapidity with which their world changed when the Nazis occupied France caught them by surprise. It is difficult to imagine such free spirits living under the tyranny of Nazi-occupied Paris. Those who could, fled; a few stalwarts stayed. Mary Reynolds was among that latter group. Duchamp was far more pragmatic. He made a decision the day after Holland fell to leave for Arcachon on the Bay of Biscay, southwest of Bordeaux.[30] From that time until he was finally able to leave for New York in 1942, Duchamp attempted in vain to coerce Reynolds into leaving her home and cats in occupied Paris and joining him variously in Arcachon, Marseilles, and Sanary-sur-Mer. In a letter to her brother, he triumphantly announced that he had managed to procure a permit that allowed travel into the Unoccupied Zone and was valid for three months and several trips. His intent was to return to Paris whenever possible and prudent to visit Reynolds. He lamented her stubborn refusal to move and listed for Hubachek her many excuses, in Reynolds's own words: "'Don't worry, no torture, no boats for six months. . . . Conditions acceptable here and no excitement.'"[31] Duchamp termed such excuses "nonsense." He voiced hope that

Reynolds would consent to follow him and spend the summer in the Unoccupied Zone. Reynolds, clearly unenthusiastic about such a plan, wrote to her brother: "To keep peace in the family, I am taking steps to join him for a month's vacation. Probably quite futile but nevertheless steps."[32] In another letter, Reynolds sent the following message to Hubachek: "Could not cross ocean, too scared, very comfortable here."[33] She was, in fact, content at rue Hallé. Her garden was yielding beans, cabbages, carrots, onions, and potatoes; the fireplace was still supplied with wood. Early in the Occupation, Reynolds had written to Hubachek that she was "hoping to do a lot of binding."[34] Unfortunately, that was not to be the case. Binding materials were in short supply; the everyday ordeal of living ate up time. Reynolds wrote, "I am busy as that one armed painter . . . also warm and I believe fattening. Am threatened with a job of book-binding but don't know where I'd find the time. Also well out of practice."[35] In an earlier letter to Hubachek, Reynolds had

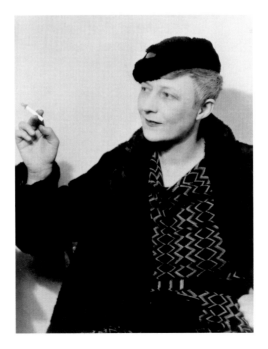

FIGURE 6
Man Ray. Photograph of Mary Reynolds, c. 1930s.

commented, "But even with life reduced to its most primitive form—or because of it—there is so little time."[36] She conceded that she was focused on "tracking down food and [giving] unorganized aid."[37] The "unorganized aid" existed in two forms: financial support of a myriad of friends through a complex system involving dozens of people, and an active role in the French Resistance.

The French Resistance was a secret organization of patriots devoted to undermining the Nazi regime and gaining back France's independence. Along with Samuel Beckett, Gabrielle Buffet (formerly Picabia), and Suzanne Picabia, Reynolds was a leader in the Resistance in Paris, giving refuge to those fleeing Nazi persecution and imprisonment and passing information to the Allies. Buffet remembered, "Around 1941, I began to work with the French Resistance. Mary was the only one to keep papers and documents at home."[38] For someone whose code name was "Gentle Mary," Reynolds was extremely courageous. Her compassion for those in need was further heightened during this period. While writing again to her brother about her contentment in Paris, Reynolds commented, "The only draw back is that the force that would otherwise make me a good life is such a black and ugly one that it can't be ignored even in retreat—and the fact that so much misery exists is sometimes overwhelming."[39]

The artist Jean Hélion was one of those whom Reynolds helped. "I was extremely fond of her, and much indebted to her. She hid me in her house in Paris for 10 days, after I had escaped from a German prisoners' camp, in 1942; when she herself was under police supervision, and she was then running a serious risk. So charming, lovely, and alive, and brave discretely [sic]."[40] Reynolds, herself, was quite circumspect about her Resistance activities in her communications home. Completely committed to the cause, she refused to do or say anything that might compromise her colleagues in the Resistance or their activities.

In trying to explain her stubborn refusal to leave Paris, even in the face of such peril, Reynolds wrote, "For the moment I have a strong feeling that anything I do will be wrong and visiting the sick and caring for the forgotten is just my job—as long as it lasts. I can't seem to leave it of my own free will. Must be a drop of protestant blood coming out late in life."[41] In contemplating the "frenzy" so many were experiencing, Reynolds wrote, "I am trying to profit by the times here . . . it is a bill in my personal life. I said try—don't laff—to make myself a better character—a little late. It is a curious life of anguish and such luxury as I have not known for a long time—the evenings more or less alone and away from the world like a desert island—and I enjoy that."[42] Her brave work in the Resistance and the care that she gave others provided her with both the anguish and luxury of which she spoke. It was only when the Gestapo was actually at her door that Mary Reynolds fled her beloved Paris.

Throughout the Occupation, Reynolds's friends continued to worry about her safety, frequently contacting both Hubachek and Duchamp for news and reassurance. By 1942, as the war deepened and Hitler's hold on Europe strengthened, concern was at its height. Kay Boyle's query of Brookes Hubachek was typical: "I was anxious to have some news of Mary. Naturally, all of those of us who love Mary are worried about her increasingly now."[43] Along the same line, Peggy Guggenheim wrote, "Do you have any news of Mary? Is she allright? . . . I wish Mary would come [here] too. But I guess she won't and maybe it is too late."[44] Correspondence between Hubachek and Duchamp also reveals their extreme worry about Reynolds's safety and well-being, with Hubachek doing all he could through Amer-

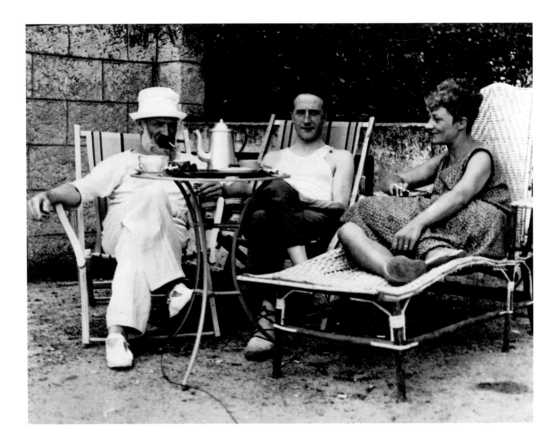

FIGURE 7
Constantin Brancusi,
Marcel Duchamp,
and Mary Reynolds
in Villefranche, France,
in 1929.

ican and Allied diplomatic channels to get her home and Duchamp continuing to try to persuade her to leave Paris and join him in North America. It is curious that both of these men continued to worry and try to take care of Reynolds when she was clearly doing a good job of it herself and for many others as well. She was neither in any immediate danger nor in a situation that she was unable to handle. Her gentle demeanor led friends and loved ones in the United States to doubt her ability to cope with the crises of war. Outwardly gentle, perhaps, but Mary Reynolds was a woman of strength, character, and determination. Her Resistance activities illustrate this, as does the fact that she was able to get herself out of Nazi-occupied France on her own, without help from either her brother or her lover.

By late summer 1942, it became apparent that Reynolds and her collaborators in the Resistance had been under Gestapo observation for some time. According to Brookes Hubachek, in the months prior to her escape, at least six of her comrades were caught and killed. Reynolds just missed this same fate. "She left her home dressed in ordinary streetwear and went across the street to a French residence where, an hour later, she saw two carloads of armed German Gestapo surround her house."[45]

Escape
In September 1942, Reynolds illegally crossed the line of Occupation and surreptitiously made her way alone to Lyons.[46] There she would wait, living anxiously in a small, mean room for eight weeks, for receipt of an exit visa and the other papers needed before she could con-

Reynolds stood out in any crowd. Although she spoke
French fluently, she had an American accent.
She was repeatedly warned not to speak
or risk bringing unwanted attention her way.

tinue her dangerous journey. Her most diffi-cult task was to locate a guide who would agree to take her across the border to Spain. A month earlier, the Nazis had tightened their grip on France, shooting any guides caught taking Jews across the border and detaining and threatening others suspected of helping refugees. Reynolds stood out in any crowd. Although she spoke French fluently, she had an American accent. She was repeatedly warned not to speak or risk bringing unwanted atten-tion her way. She quietly continued her nego-tiations with "passeurs," but was not successful in locating anyone willing to take on such a risk. In mid-November, the Nazis marched into Lyons on their way to Marseilles. Shortly after their arrival, Reynolds went with her American passport to the Spanish consulate, where she was able to bribe a Spanish official and received a visa in only one day. On Novem-ber 25, she was visited by the police and real-ized that she would have to leave immedi-ately.[47] The following day, Reynolds left for Pau, where she hoped to arrange to cross the Pyrenees by freight car. Unfortunately, the railway workers who had so heroically been smuggling refugees across the border had recently been rounded up and sent to concen-tration camps, foiling this method of escape. Reynolds's only option appeared to be one that she had hoped to avoid: walking across the Pyrenees into Spain. Many of the passes were higher than those in the Alps; the route was fraught with danger from both border patrols and the elements.

After weeks of searching, Reynolds finally located a guide willing to take her across the border for thirty-five thousand

francs. Initially, she turned the offer down as being too expensive, but rushed back when she learned that the Gestapo had again found her and left a message with her landlady demanding her appearance at the Kommissäriat the following morning. Her traveling com-panions were two Jewish men, a Jewish boy, and a mountain guide. They traveled light, carrying only their essentials. In addition, Reynolds carried a roll of paintings by her friend Man Ray. Prior to leaving for America, he had entrusted her with some of his paint-ings and books for safekeeping during the conflict. When fleeing Paris, Reynolds had hurriedly gathered a few of the unframed paintings in the hope of being able to return them to the artist, who was in California.[48]

The journey contrasted magnificent views with an arduous physical challenge. Walking heel to toe up ravines and over swollen gul-lies, the group endured extreme heat at the lower altitudes and sleet storms at the higher elevations. The physical exertion in the thin mountain air slowed their progress. On the eve of the third day, the party joyously reached the Spanish border. Their celebrating was short-lived, however. Two of the refugees were apprehended by the local police and arrested. Reynolds was the only one with proper papers, which in itself aroused suspicion. She was detained with the rest of the group and held six days for questioning. In the end, Reynolds was released, but not allowed to leave, because the town of Canfranc, not Isaba, where she was, had been put on her passport as the Span-ish port of entry. In order for her to leave, she needed to have the Canfranc stamp. Reynolds's American money and Banque de France draft were of no value to her in Isaba; with no ready currency to use for bribes or travel, she was stranded. Fortuitously, an anonymous Span-ish gentleman sought her out in her hotel and secretly offered her the loan she needed, ask-

ing in return only that she post a love letter to his fiancée in Brazil. When Reynolds attempted to give him her greatest treasure—her wedding band—as collateral, he gallantly refused.

On December 14, 1942, Reynolds happily cabled her brother of her arrival in Madrid. In his euphoric letter to Duchamp relaying this news, Hubachek wrote, "The cable from Madrid was like getting her back from the dead."[49] Acting upon a suggestion from the U.S. State Department, Hubachek had earlier prepaid Reynolds's fare of $942.90 to cover passage on Pan-American Airways' *Yankee Clipper*.[50] On the morning of December 31, he received another cable: "Awaiting plane probably January sixth. Love to all and Happy New Year."[51]

On January 6, 1943, Mary Reynolds boarded the aircraft bound for New York. She arrived with a badly infected leg from a wound sustained during a fall on her walk through the mountains, but her spirits were soaring. The Office of Strategic Services (O.S.S.), the forerunner of the Central Intelligence Agency, debriefed her at the Waldorf Astoria Hotel, where she stayed until she regained her strength. Reynolds was glad of the opportunity to detail some of the Resistance activities, as well as Nazi border guard locations. She also protested the lack of discretion of some of the radio broadcasts heard in the Occupied Zone that mentioned people by name, gave locations of Resistance activities, and generally threatened the effectiveness of the Resistance and the safety of those involved.

The Final Years: 1943–1950
Reynolds and Duchamp stayed in New York for the duration of the war, taking up residence once again in Greenwich Village.[52] They socialized with old friends and other artists exiled in New York, such as the Frederick Kieslers and Alexander Calder. In California,

a surprised Man Ray received the role of paintings Reynolds had rescued. He was especially delighted that *Observatory Time— The Lovers*, now known as *The Lips* (1932–34; private collection), was among them.[53]

By July 1944, Reynolds was well enough to begin looking for employment. Fine bookbindings were not in demand; in any case, rationing meant that materials she needed were reserved for military use. She received her Civil Service rating and applied for a job with the O.S.S. She hoped that her experience in the French Resistance and facility with languages, including French, German, and Italian, would be of assistance in procuring a job with the foreign service. The interviewer reported her to be, "Tall, good appearance, alert and a little bit the aggressive type."[54] Although several letters were written on her behalf by some of her brother's government contacts, and she gained a security clearance, Reynolds was not assigned a position. On August 18, 1944, Major S. W. Little reported that the "File sent to MO Registry as of 27 July marked no interest (age)." Mary Reynolds was fifty-two at the time.

Although Reynolds had always planned to return to Paris after the war, Duchamp wished to remain in New York. He found the pace, the scale, and the opportunities among American collectors inordinately seductive. Once again, he tried, unsuccessfully, to persuade Reynolds to stay with him, this time in New York. Calder remembered that a "moulting cat adopted her on 11 St., and Marcel thought that might well be the means of keeping her in America."[55] Her love of cats notwithstanding, Reynolds returned to Paris six weeks after the end of the war. She was euphoric to be home at 14, rue Hallé, among her books, her furniture, her cats. Although Duchamp rejoined her in 1946, the pull of New York was too great. Reynolds wrote of her "anguish" to their mutual friends, the

Hoppenenots.[56] Duchamp's departure in early January 1947 left Reynolds widowed again, albeit happy in her adored Paris.

From 1945 to 1947, Reynolds was the Paris representative for the avant-garde magazine *View*, soliciting among her artist and writer friends for the editor Charles Henri Ford. Correspondence between Reynolds and Ford reveals many of the well-known problems, especially that of cash flow, associated with this short-lived but influential publication. In a letter to Ford, Reynolds wrote, "So for months I've been murmuring VIEW and feeling like a worm. For an american to beg material which the french pay for is not at all a nice position."[57] She approached writers such as Jean Genet and André Malraux and old friends like Jean Cocteau and Georges Hugnet. She worked tirelessly and enthusiastically; a postscript to a March 3, 1946, letter to Ford reads, "VIEW seems to bloom. 3VVVs for VIEW."[58]

Reynolds does not appear to have continued her bookbinding to any great extent upon her return to Paris. *Saint Glinglin* (cat. no. 6) is one of the few bindings that she created in this period. Perhaps she needed the synergy that Duchamp provided, or perhaps the magic of the moment was over. The war had altered not only the physical landscape of Europe, but the milieu of the artists as well. The revolution that was Surrealism was being rapidly eclipsed by a new wave of artists kindling the flames of abstraction. The central figures of Surrealism had been scattered all over the globe as well. Some, like Duchamp, stayed in the United States after the war. Others returned to a Europe whose spirit had been catastrophically broken and would need years to heal. Breton had seen his influence significantly diminished while he was in New York. Reynolds herself seems to have lost the passion for her art. That spot in her soul was filled instead with the quiet guilt of a survivor and the serenity often found in one's advancing years. Reynolds's health had also been broken by the deprivations of the war and the hardships endured during her escape. In June 1949, she traveled to La Preste to take a cure. In a postcard to Flanner, she wrote, "We pass 21 days of insomnia, fluttering heart, stomach and nerves and constipation—hoping to kill the coli bacilli before we succumb."[59] The mineral waters of La Preste were believed by many to kill intestinal bacteria *coli bacilli*. Flanner noted at the bottom of the postcard, "Nearly last words from dear Mary." By April 1950, Reynold's health had deteriorated to the point that she

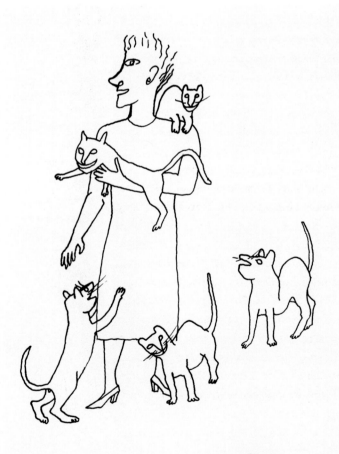

checked into the American Hospital in Neuilly. Upon learning this, Duchamp became acutely concerned; he queried all of their friends in Paris for information about her condition. Of Roché, he asked, "Is it only the kidneys, or kidney? Strange that the infection is not vanishing, even gradually."[60] He asked the Crottis to keep him informed. In a subsequent letter to Roché, Duchamp speculated, "I have never uttered the word cancer, but do you think that there is a dreadful possibility there? Don't hesitate to tell me."[61] Duchamp finally made the voyage to France at the end of September. He found Reynolds's condition desperate. "Her brain is so lucid, her heart and her lungs are in an almost perfect state, that one hardly understands that it is impossible to attempt anything in the way of a 'cure.'"[62] A visit to the clinic at Neuilly revealed Reynolds "had a dreadful tumour [of the uterus] which no one detected and cannot now be operated."[63] Her condition was hopeless. Four days after Duchamp arrived at her bedside, she slipped into a coma. At 6:00 a.m. on September 30, 1950, Mary Reynolds died at home on rue Hallé, with her beloved Marcel Duchamp at her side. Her funeral was held on October 3 at the American Cathedral on the Avenue Georges V.

Duchamp stayed on at 14, rue Hallé, taking care of Reynolds's affairs, cleaning the house, and most importantly, organizing her bindings, as well as the books, art, and ephemera that she had gathered during her three decades in Paris. These he had carefully packed and shipped to her brother, who had decided to donate the collection to The Art Institute of Chicago in his sister's memory. Hubachek and Duchamp worked assiduously on the organization and publication of the collection for nearly six years. When the collection catalogue, *Surrealism and Its Affinities: The Mary Reynolds Collection*, was pub-

lished in 1956, Hubachek made certain that as many of his sister's friends as he could locate received a copy. He obtained names and addresses not just from Duchamp, but from Cocteau, Barnes, Calder, Flanner, and others. Tributes poured in. One of the most touching was from Cocteau, who wrote to Duchamp, "My very dear Marcel—It is rare that death leaves warm ashes. Thanks to you, this is what is happening for Mary. I congratulate and embrace you."[64]

In a letter to Hubachek, Flanner captured the love and admiration Mary Reynolds had inspired from so many in her life:

Perfect memorial to darling Mary. How intimate she was with the artery-stream of Paris, in the pulse of its creators, major and minor. There was something *immediate* in her sense of appreciation, she seemed to be right at the side of writers and artists as they became themselves, so she was a continuous witness. I loved Mary dearly; her gayety, the special timbre of her voice, her laughter, her smile which was often so contemplative, oh, she was a captivating woman.[65]

The Mary Reynolds Collection is all that Brookes Hubachek and Marcel Duchamp envisioned. As a core collection of published materials by the Surrealists, the five hundred printed pieces include all of the important documents of Surrealism, as well as a multitude of ephemera, so much of which might otherwise have been lost. But Mary Reynolds's true legacy is the part of the collection that contains her magical bindings, an output of fewer than seventy. It is in these remarkable works that the spirit of Mary Louise Reynolds lives on.

A Selected Catalogue of Bookbindings by Mary Reynolds

1. Ubu Roi: Drame en cinq actes (King Ubu: Play in Five Acts)

All bookbindings illustrated here are in the Mary Reynolds Collection at The Art Institute of Chicago.

This binding is perhaps the best known and most successful of the collaborations between Mary Reynolds and Marcel Duchamp. On November 26, 1934, Duchamp visited his close friend Henri Pierre Roché in Arago and excitedly reported on a binding he had just designed for Alfred Jarry's *Ubu Roi* that Mary Reynolds was going to execute.[66] Reynolds and Duchamp created out of the binding itself an extraordinarily clever pun. Both the front and back covers are cut-out U's covered in rich earth tones; the spine is a soft caramel B. The endpapers are made of black moiré silk. A gold crown, signifying the puppet king, is imprinted on the front flyleaf and visible through the front cut-out U. The author's name is imprinted in gold on the back flyleaf and is similarly visible through the back U. The binding spread open spells "UBU."

Reynolds must have spent considerable time executing this binding. We know from a letter from Duchamp, responding to a question from Katharine Kuh, the Art Institute's curator of twentieth-century art from 1948 to 1959, that the binding was not completed until 1935.[67] It is expertly and lovingly crafted. Both Duchamp and Reynolds were so pleased with the final work, that another copy was bound

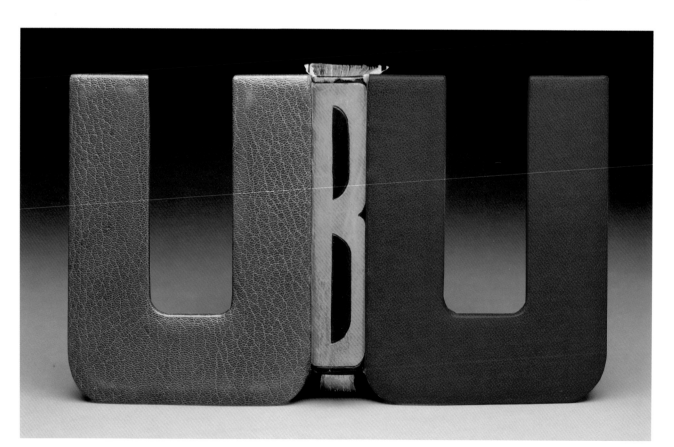

identically for the American collectors Walter and Louise Arensberg, which is now in the Philadelphia Museum of Art.

2. Gestes et opinions du Docteur Faustroll, pataphysicien (The Exploits and Opinions of Doctor Faustroll, Pataphysician)

Reynolds created this binding based on Duchamp's windows, *Fresh Widow* (1920) and *Bagarre d'Austerlitz* (*Brawl at Austerlitz*) (1921). In 1936 Duchamp returned to the concept of his windows and had the *Brawl* printed on paper and celluloid for André Breton's *Au Lavoir noir* (Paris: Editions GLM, 1936). It was enclosed loose in each of the seventy copies. Presumably, Reynolds revisited this concept with him with this inspired *fenêtre* binding as a result.

Duchamp created his windows with opaque panes: functional objects that did not function, another of his plastic puns. Unlike *Fresh Widow*, the window panes on this binding are not completely darkened, but dotted

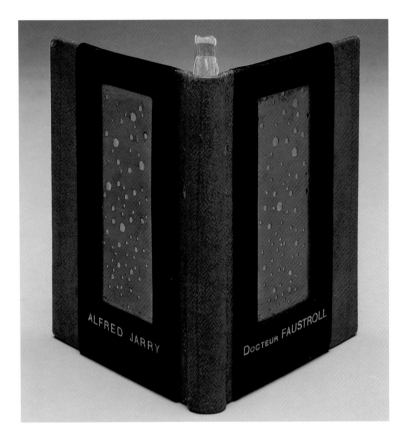

OPPOSITE PAGE AND LEFT
1. Mary Reynolds (American, 1891–1950) and Marcel Duchamp (American [born France], 1887–1968). UBU ROI: DRAME EN CINQ ACTES (KING UBU: PLAY IN FIVE ACTS) by Alfred Jarry. Paris: Librairie Charpentier et Fasquele, 1921. Binding: morocco, levant, and niger (goatskins) with silk and glassine endpapers.

2. Mary Reynolds and Marcel Duchamp. GESTES ET OPINIONS DU DOCTEUR FAUSTROLL, PATAPHYSICIEN (THE EXPLOITS AND OPINIONS OF DOCTOR FAUSTROLL, PATAPHYSICIAN) by Alfred Jarry. Paris: Librairie Stock, 1923. Binding: brown leather stamped in herringbone pattern, black morocco (goatskin), copper sheeting, and green glassine endpapers.

with uneven holes, inviting the viewer to look in, but allowing only a glimpse of the contents.

"Pataphysics," a concept Alfred Jarry (1873–1907) introduced in this book, is the study of a realm additional to metaphysics, a science of imaginary solutions. Pataphysics welcomes all scientific explanations for the universe, suspending all values moral, aesthetic, and otherwise. Jarry regarded reality as a cosmic joke.

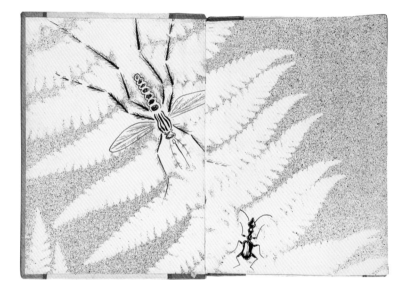

3. Mary Reynolds and Marcel Duchamp. RROSE SELAVY by Marcel Duchamp. Paris: GLM, 1939. Inscription on half-title page: Chère Mary / Marcel (Dear Mary / Marcel). Binding: sienna, pink, and beige morocco (goatskins), gray cardboard, string, and painted endpapers with insects drawn in India ink, probably by Reynolds.

3. Rrose Sélavy

In the fall of 1940, Duchamp had a letterpress block made for his almost-completed project *Boîte-en-valise* (*Box in a Valise*). Approximately three hundred gray cards with "De ou par Marcel Duchamp ou Rrose Sélavy" ("Of or by Marcel Duchamp or Rrose Sélavy") were printed for the lid of the inner part of the box. Reynolds similarly used a trial blind stamp with multiple strikes on the same gray cardboard. On both the front and back covers of this binding, she continued to refine her Surrealist vocabulary by bringing together unpredictable materials: rich leathers coupled with common twine and a discarded card-

board proof. Duchamp created his feminine alter ego, Rrose Sélavy (a homonym in French for "Eros, c'est la vie," or "Eros, that is life"), in 1920. She was crude, vulgar, and completely irresponsible.

4. Maison de santé (Mental Hospital)

The dominant element of this binding is the cut-out star on the front and back covers, which Reynolds adapted from the star that often appeared under Jean Cocteau's signature. In 1916, Cocteau visited the French poet Guillaume Apollinaire (1880–1918) in the hospital where he was recovering from a head wound received in battle. Cocteau, like many other Surrealists, worshipped Apollinaire, considering him one of the seminal influences of the movement. The shape of Apollinaire's scar was the inspiration for Cocteau's signature star.

In 1925, Cocteau was committed to the Urban Baths in Paris for detoxification treatment for his opium addiction. His stay there was the impulse for this book. Reynolds affirmed this association by making the "Cocteau star" the most significant design feature on both the front and back covers. The material that she chose for the binding is a seductive alabaster vellum that suggests the white powder of the narcotic itself. The identification of the star with Cocteau, and Cocteau with opium, cannot be overlooked or ignored: it is key to the book and to the binding.

5. La Machine à écrire (The Typewriter)

The pivotal component of this binding is its pure simplicity, both conceptually and materially. Reynolds used a traditional binding material, vellum, for the spine. It is stamped in gold and, as always, carries Jean Cocteau's star at the bottom (see cat. no. 4). The front

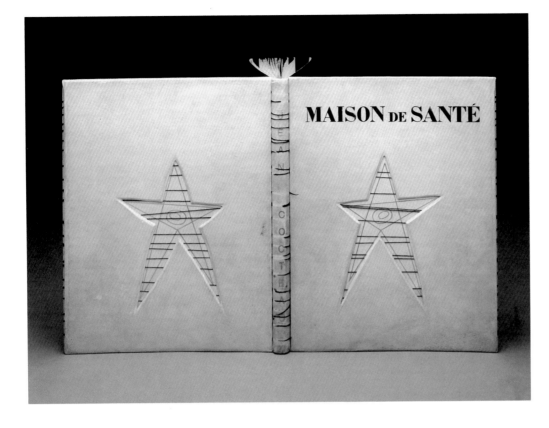

4. Mary Reynolds.
MAISON DE SANTE
(MENTAL HOSPITAL)
by Jean Cocteau.
Paris: Editions Briant-
Robert, [1926].
One of five hundred
copies on Rives
paper printed, num-
bered, and signed
by the artist/author.
Binding: full vellum
(untanned calfskin),
black threads, and
maroon endpapers.

5. Mary Reynolds.
LA MACHINE A ECRIRE
(THE TYPEWRITER)
by Jean Cocteau.
Paris: Gallimard, 1941.
Binding: vellum
(untanned calfskin),
and typing paper.

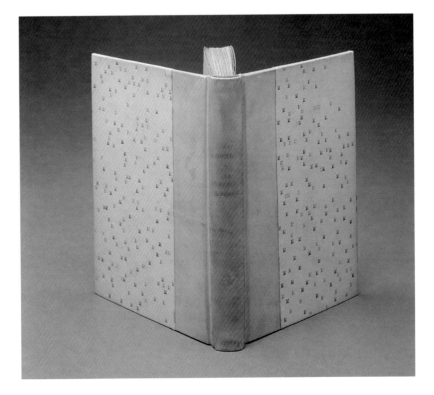

and back boards are covered in typewriter paper with upper-case M's typed alternately in red and black, symbolizing the *machine*. Could the M's also be a reference to Marcel? Simple, direct, yet the concept is brilliant.

Reynolds considered Cocteau a close friend, even after Breton had banished him from the Surrealist circles. In all, she bound twenty-four books by Cocteau for herself. While some are design bindings, many are simple quarter vellum bindings over decorative boards. All are imprinted in gold with the Cocteau star.

6. Saint Glinglin

This is one of the most playful, yet difficult to understand, of Reynolds's bindings. It may also be the last binding that she created. Saint Glinglin appears to be fictitious, but from the green of the binding and the serpent slithering up the spine with his fangs reaching toward "Glinglin" onlaid in leather letters on the front board, one suspects that, fictitious or not, he may be Irish. This teacup handle may also suggest the reader's ability to pick up the book and pour out its contents.

The author, Raymond Queneau, was an experimental novelist who drew his inspiration from childhood remembrances. His stories were told in a childlike manner with ironic exaggerations, slapstick wit, and the ubiquitous pun. Queneau was one of Mary Reynolds's close friends. In addition to enjoying his friendship, she must also have enjoyed his fiction: in all, twelve books written by Queneau were bound by Reynolds.

6. Mary Reynolds. SAINT GLINGLIN by Raymond Queneau. Paris: Gallimard, 1948. Binding: green and tan morocco (goatskin), pottery cup handle in the shape of a serpent, and French marbled endpapers.

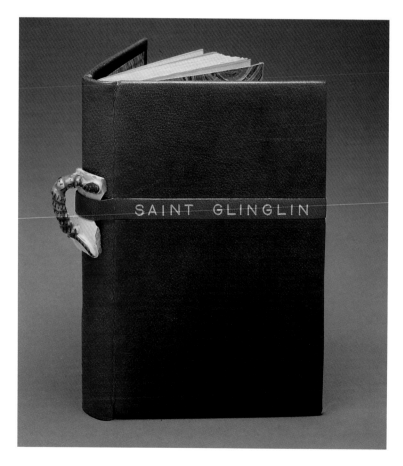

7. La Science de Dieu ou la création de l'homme (The Knowledge of God or the Creation of Man)

The toad skins laid on both the front and back covers of this book are obvious reference to the subject of evolution found in the title of *La Science de dieu*. In true Surrealist fashion, however, the book is not what it appears to be. The author, Jean Pierre Brisset, was not referring to physical evolution, but to the evolution of language.

The genus of toad that Reynolds used is *Bufo*, a common variety that exists worldwide. Reynolds used a number of alluring and unexpected skins, including ostrich and boa constrictor, which were not difficult to obtain in Paris during the 1920s and 1930s. In these toads, the flaps of skin behind each eye are glands called parotids that secrete poison.

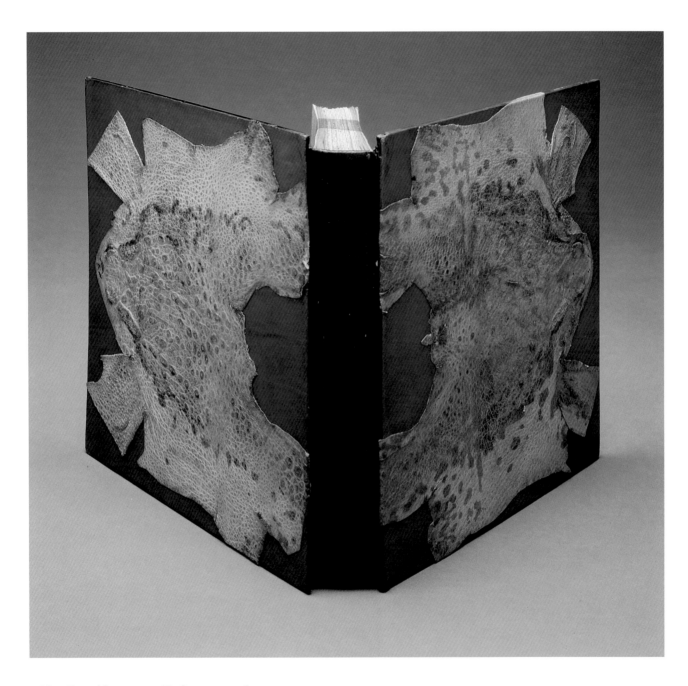

7. Mary Reynolds. LA SCIENCE DE DIEU OU LA CREATION DE L'HOMME (THE KNOWLEDGE OF GOD OR THE CREATION OF MAN) by Jean Pierre Brisset. Paris: Chamuel, Editeur, 1900.

Binding: green and black calfskin, full *Bufo* toad skins, and printed and glassine endpapers.

8. Mary Reynolds. ODILE by Raymond Queneau. Paris: Gallimard, 1937. Inscribed on half-title: à Mary Reynolds / avec ma bien / vive sympathie / Queneau (to Mary Reynolds / with my enthusiastic friendship / Queneau). Binding: black calfskin, vellum (untanned calfskin), India ink, and Japan paper.

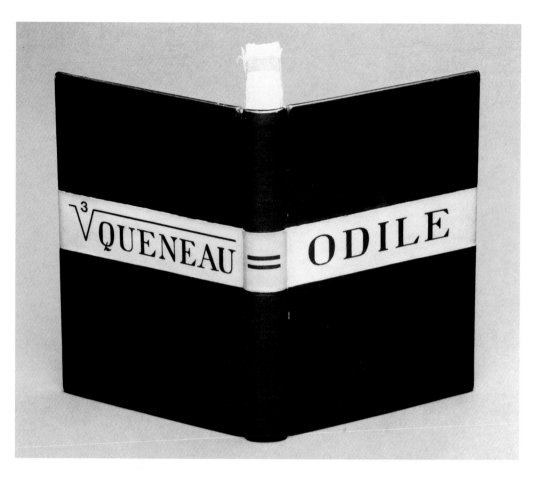

8. Odile

In addition to the use of elaborate and unpredictable materials, Reynolds employed such devices as unconventional placement of titles and author names to achieve her artistic goals. This binding of black calf with an ivory vellum panel, on which is hand-lettered the title on the front board and the name Queneau on the back, is extraordinarily elegant. It demonstrates clearly Reynolds's sound sense of design and proportion as well as her ability to create unpredictable fantasy in a completely unaffected manner.

During his Surrealist period, the French writer Raymond Queneau exhibited a flair for verbal juggling, black humor, puns, and ironic hyperbole. His novels, such as *Odile*, present familiar settings from which emerges a vision of an absurd world.

9. Un Rude Hiver (A Harsh Winter)

Mary Reynolds chose to bind this minor novel by Raymond Queneau in traditional morocco leather, and then departed into the realm of fantasy when she applied to the spine a thermometer that appears to be broken at zero degrees Celsius. The front doublure has an inlaid blue leather strip indicating cold, while the back doublure has a red leather strip denoting heat. With these few devices, Reynolds informed us of the nature of *Un Rude Hiver.*

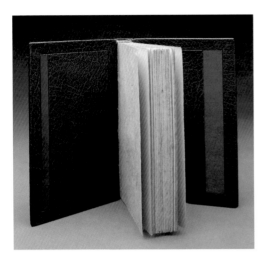

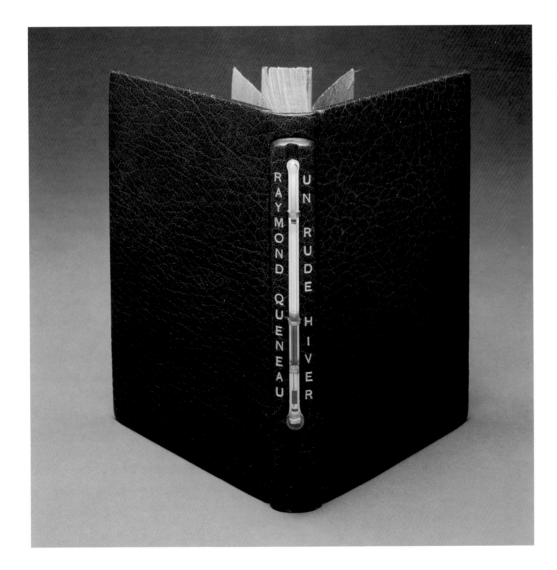

ABOVE AND LEFT

9. Mary Reynolds. UN RUDE HIVER (A HARSH WINTER) by Raymond Queneau. Paris: Gallimard, 1939. First edition; one of thirty copies on Lafume-Navarro paper. Binding: full gray morocco (goatskin), broken thermometer, and morocco doublures (inside linings of cover).

10. Secrets de la jungle (Jungle Ways)

William Seabrook's fame rests on his bizarre tales of the supernatural. On the binding for *Secrets de la jungle*, a collection of exotic stories of primitive cannibals, Mary Reynolds cleverly combined images of flora and fauna from the jungle through her use of botanical imagery made with reptilian leather. The use of a boa constrictor skin suggests the mystery of the jungle described in the book and hints at the savage cannibalism with which these stories are preoccupied.

11. Le Vrai Visage du Marquis de Sade (The True Face of the Marquis de Sade)

The Marquis de Sade was admired by the Surrealists for his obscene writings, scandalous theories on the nature of sex, and his commitment to all things pleasurable. In all, Sade spent more than twenty-seven years of his

life in various prisons because of his unusual sexual proclivities.

Mary Reynolds coyly alluded to Sade's obsession by placing the binding in bondage. The black calfskin-covered boards suggest the darkness and perversion of Sade's erotic ideals. The red morocco diagonal bands not only tie up the book, but also suggest the welts that result from some of Sade's favored activities.

12. Le Surmâle (Superman)

Alfred Jarry, best known for his works that pioneered the Theater of the Absurd, wrote the first (1902) significant, modern tale of "superman." The account is framed around the story of Messalina, third wife of the Roman Emperor Claudius, known for her prodigious sexual endurance. Jarry imagined a male counterpart who, after shattering a world's endurance record, is paired up with the ultimate aphrodisiac: a machine created to inspire love and provide supreme satisfaction. The superman's power, greater than that of the machine, inspires such passion that the mechanical being becomes white-hot, too much for flesh and blood to bear: superman dies.

Mary Reynolds's binding alludes both to the romantic aspect of love, with the image of the butterfly wrapping the book, as well as to Jarry's erotic love machine, with the metal corset stay on the spine arising from the delicate, defenseless butterfly like an erection bursting forth with lust, desire, and the need to dominate. The mauve-colored endpapers printed in a wire-mesh pattern extend further still the theme of mechanical dominance. Even the near monotone palette speaks of the control of the mechanics of sex over intimate tenderness. Overtones of the potential self-destructiveness of unbridled passion are omnipresent.

10. Mary Reynolds. SECRETS DE LA JUNGLE (JUNGLE WAYS) by William Seabrook. Translated by Suzanne Flour. Paris: Editions Jacques Haumont, 1931. Inscribed on the original paper cover: For Mary Reynolds / God bless her. / "Hommage de / l'auteur" / W. / B. / Seabrook. Binding: green morocco (goatskin), boa constrictor, and brown paper.

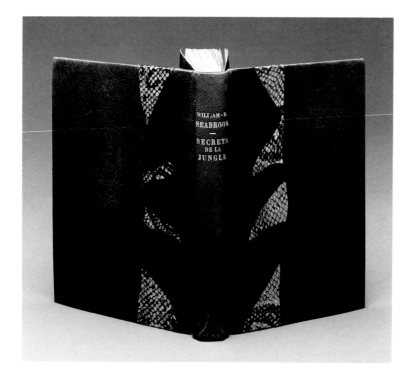

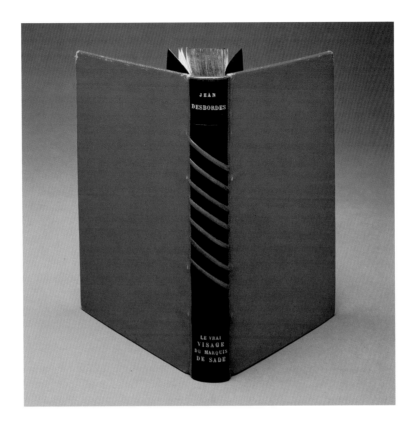

11. Mary Reynolds. LE VRAI VISAGE DU MARQUIS DE SADE (THE TRUE FACE OF THE MARQUIS DE SADE) by Jean Desbordes. Paris: Edition de la Nouvelle Revue Critique, 1939. Inscription on half-title: A Mary Reynolds / si bienfaisante, que / j'aime tendrement et / respectueusement / Jean Desbordes (To Mary Reynolds / so gracious, whom / I love tenderly and / respectfully / Jean Desbordes). Binding: red morocco (goatskin), black calfskin, and gold stamping.

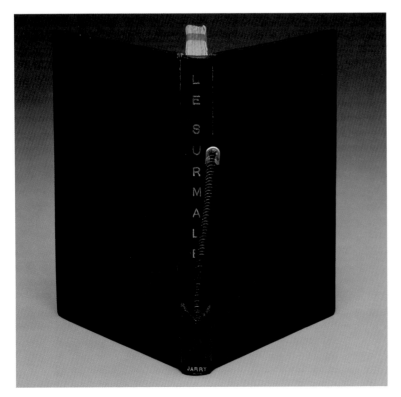

12. Mary Reynolds. LE SURMALE (SUPERMAN) by Alfred Jarry. Paris: Faquelle Editeurs, 1945. Binding: black leather, brown morocco (goatskin), corset stay, and printed endpapers.

13. Les Yeux fertiles (The Fertile Eyes)

Paul Eluard, a leading poet of French Surrealism, and his wife Gala, who later married Salvador Dali, were close friends of Mary Reynolds and Marcel Duchamp. Eluard and Reynolds both stayed in Paris during the Occupation and were active together in the French Resistance.

Les Yeux fertiles is a stunning celebration of love and some of Eluard's finest poetry. Reynolds's choice of the beautiful, mysterious skin of the ostrich for the binding suggests the tender, elusive qualities of love. This binding is the only one in the Art Institute's collection that did not come from Mary Reynolds's own library. It came from the estate of the French poet Georges Hugnet. There is a note in Hugnet's hand indicating that the binding was executed by Mary Reynolds in 1940. Consequently, this is one of the few bindings by her that can be dated with absolute certainty.

14. Les Mains libres (The Free Hands)

This binding is one that is most closely associated with the Mary Reynolds Collection: it was chosen as the cover image for *Surrealism and Its Affinities: The Mary Reynolds Collection* (Chicago: The Art Institute of Chicago, 1956). It is another of Reynolds's and Duchamp's plastic puns. The kid gloves onlaid on both front and back boards are slit open, symbolically freeing the hands. The sumptuousness of the materials, including the silk endpapers, lends an air of elegance to this unexpected and amusing treatment of Man Ray's and Paul Eluard's stunning collaboration.

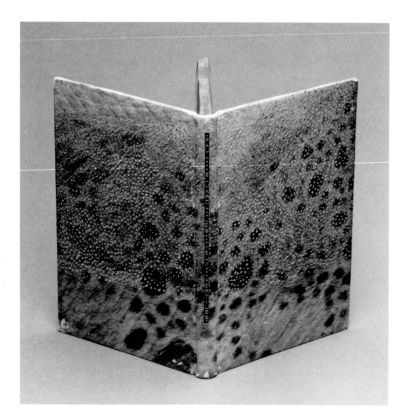

13. Mary Reynolds.
LES YEUX FERTILES
(THE FERTILE EYES) by Paul
Eluard. With a portrait
and four illustrations
by Pablo Picasso.
Paris: G.L.M., 1936.
Inscribed in red ink: à
Georges Hugnet
un des rares poètes
que j'aime et bien, Paul
Eluard (to Georges
Hugnet, an exceptional
poet, whom I love very
much, Paul Eluard).
Binding: ostrich leather,
calfskin, and printed
endpapers.

14. Mary Reynolds.
LES MAINS LIBRES
(THE FREE HANDS)
Drawings by Man
Ray; illustrated by the
poems of Paul Eluard.
Paris: Editions Jeanne
Bucher, 1937. One of
675 copies printed;
inscribed on half-title:
à Mary Reynolds /
affectionately / Man
Ray / Dec. 24 1937 /
Paul Eluard. Binding:
tan morocco
(goatskin), kid gloves
slit open, pink sponge
rubber doublures
(inside lining of
covers), and silk
endpapers.

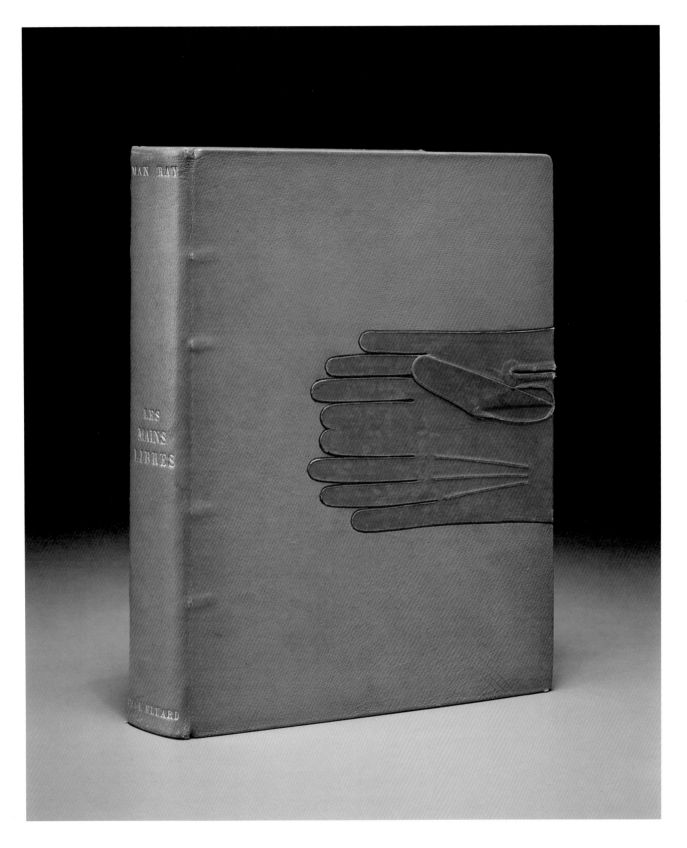

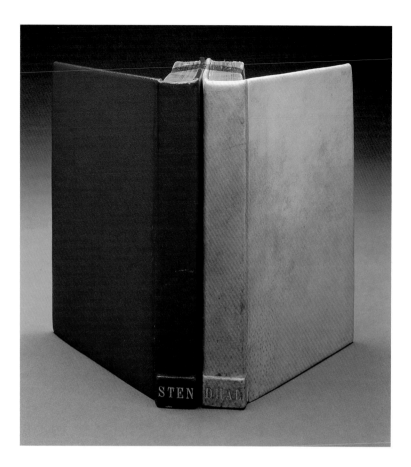

15. Mary Reynolds.
LE ROUGE ET LE BLANC
(LUCIEN LEUWEN) (THE RED
AND THE WHITE [LUCIEN
LEUWEN]). Posthumous
novel (1834–38)
by Stendhal (Marie-
Henri Beyle).
Edition based on the
Grenoble manuscript
with a history of
the text, notes, and vari-
ants by Henri
Ramboud. Paris:
Editions Bossard, 1929.
Binding: red morocco
(goatskin), and vellum
(untanned calfskin).

15. Le Rouge et le blanc (Lucien Leuwen) (The Red and the White [Lucien Leuwen])

Best known for his novel *Le Rouge et le noir*, at his death Stendhal left an unfinished novel, *Le Rouge et le blanc*, also known as *Lucien Leuwen*, which is in two volumes. Here Mary Reynolds has cleverly covered the spine of the first volume in "rouge" morocco goatskin and the second volume in "blanc" vellum. The author's name runs across both volumes, split between the two—a reference to Stendhal's notorious lack of identity. He spent his life as a wanderer, using 170 pen names during his career, and living his life through his characters and their exploits. By placing "Sten" at the foot of volume one and "dhal" at the foot of volume two, Reynolds acknowledged the lack of defined character and cohesive personality. She presented the author in parts, as Stendhal, in fact, saw himself.

16. Ubu Cocu, restitué en son intégrité tel qu'il a été représenté par les marionettes du Théâtre des Phynances (Ubu Cocu, Restored to Its Integrity as It Was Presented by the Puppets of the Théâtre des Phynances)

Mary Reynolds bound this Alfred Jarry sequel to the adventures of Ubu, the puppet king, nearly ten years after binding *Ubu Roi* (cat. no. 1) in collaboration with Marcel Duchamp. This binding, very reminiscent of that effort, is another plastic pun with the covers of the binding constructed of the letters of the title, "Ubu Cocu." The front and back boards each have a large U onlaid in morocco; the spine shows an elongated b. When the covers are spread open, the cover spells "UbU." The letters "co" appear within the front U; the letters

"cu" appear through the back U. These additional onlaid letters in lemon yellow and gray complete the title, spelling "UbU CoCu."

17. Hebdomeros

Arturo Schwarz asserted that this binding is another Mary Reynolds/Marcel Duchamp collaboration.[68] The skin that Reynolds used for the covers is an extremely porous, heavy leather, possibly from the body of an ostrich. The spine is fluted with lighter leather inlays. The binding itself appears to be an ambitious exercise in perspective and spatial relationships. The title is laid on the front board on a diminishing plane so that the letters appear to be receding. The back cover, with the author's name onlaid, is treated in the same manner. When the covers are open and the binding is observed from the spine, two separate planes are apparent. The first plane is the binding itself; the second is the one on which the receding letters rest.

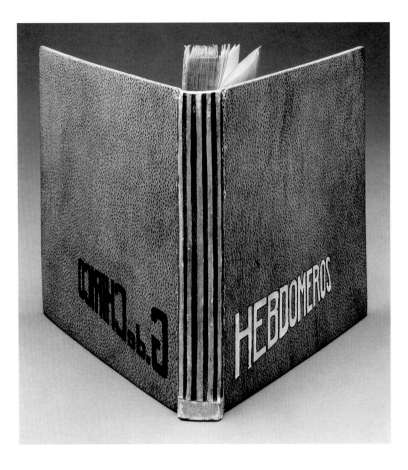

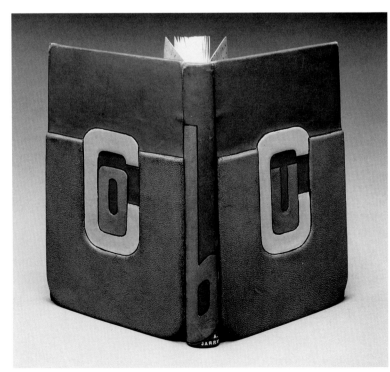

16. Mary Reynolds. UBU COCU, RESTITUE EN SON INTEGRITE TEL QU'IL A ETE REPRESENTE PAR LES MARIONETTES DU THEATRE DES PHYNANCES (UBU COCU, RESTORED TO ITS INTEGRITY AS IT WAS PRESENTED BY THE PUPPETS OF THE THEATRE DES PHYNANCES) by Alfred Jarry. Paris-Geneva: Editions des Trois Collines, [1944]. Binding: brown calf and morocco (goatskin) in various colors.

17. Mary Reynolds and Marcel Duchamp. HEBDOMEROS by Giorgio de Chirico. Paris: Editions du Carrefour, 1929. One of 263 copies printed on Pannekock Dutch paper. Binding: unidentified leather, calf, Niger (goatskin) doublures, and silk endpapers.

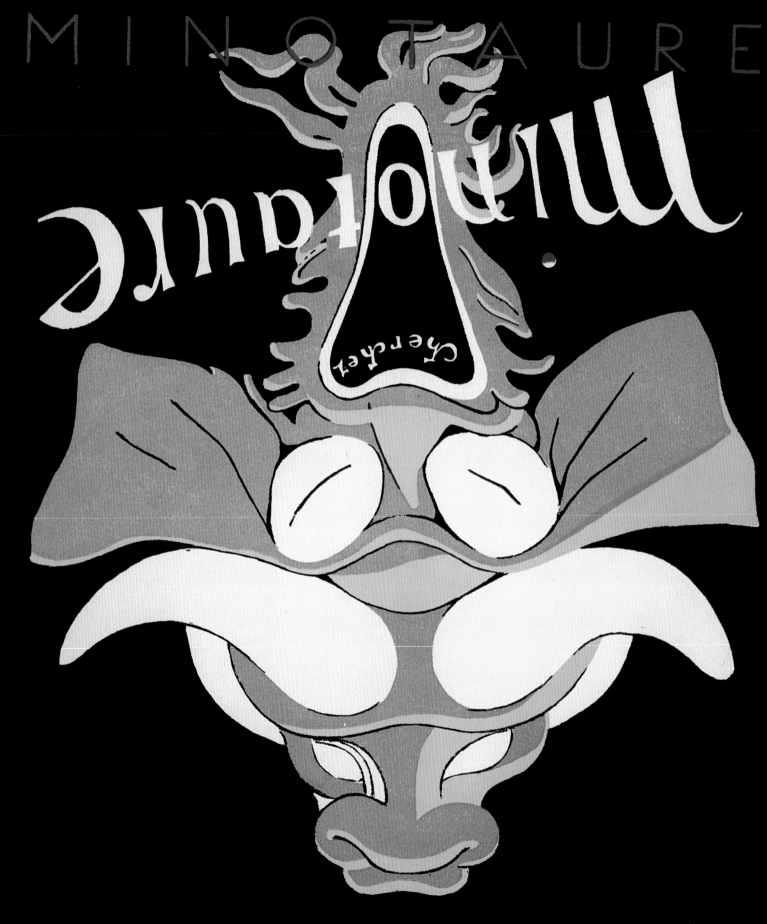

Documents of Dada and Surrealism:
Dada and Surrealist Journals
in the Mary Reynolds Collection

IRENE E. HOFMANN

Ryerson and Burnham Libraries
The Art Institute of Chicago

The Mary Reynolds Collection, which entered The Art Institute of Chicago in 1951, contains, in addition to a rich array of books, art, and Reynolds's own extraordinary bindings, a remarkable group of periodicals and journals. As a member of so many of the artistic and literary circles publishing periodicals, Reynolds was in a position to receive numerous journals during her life in Paris. The collection in the Art Institute includes over four hundred issues, with many complete runs of journals represented. From architectural journals to radical literary reviews, this selection of periodicals constitutes a revealing document of European artistic and literary life in the years spanning the two world wars.

In the early part of the twentieth century, literary and artistic reviews were the primary means by which the creative community exchanged ideas and remained in communication. The journal was a vehicle for promoting emerging styles, establishing new theories, and creating a context for understanding new visual forms. These reviews played a pivotal role in forming the spirit and identity of movements such as Dada and Surrealism and served to spread their messages throughout Europe and the United States.

For the Dadaists, publications helped to distinguish and define Dada in the many cities it infiltrated and allowed its major figures to assert their power and position. As Dada took hold in cities throughout Europe, each manifestation was unique, reflecting the city's own artistic and social climates. Every incarnation of Dada spurred a proliferation of new journals and reviews that announced Dada activities, attracted new members, and further established a Dada program.

Similarly, for the leaders of Surrealism, the journal was a powerful means by which they could impose their agenda and assert their politics. The journal was an ideal vehicle for Surrealists to disseminate their manifestos and establish their presence across Europe. Publications introduced the group's poetry and imagery and provided a forum for interpretations of dreams and experiments with automatic writing and imagery, and offered a medium for exploring relationships between text and image. In the later, less stable years of Surrealism, the journal also served as a stage for bitter conflicts between the group's members.

Since so many of the initial manifestations of Dada and Surrealism were public gatherings, demonstrations, and other similar activities, the journals, through their announcements and coverage of these events, provide invaluable documentation of the evolution of

FIGURE 1

Minotaure 11, ed. Albert Skira (Paris, 1938), cover design by Max Ernst. All journals illustrated in this essay are in the Mary Reynolds Collection at The Art Institute of Chicago.

Dada and Surrealist journals were vehicles for promoting emerging styles, establishing new theories, and creating a context for understanding new visual forms.

Dada and Surrealism. Their passionate coverage of art, politics, and culture captures the climate that fueled the Dada and Surrealist revolts and contributes greatly to our understanding of the often enigmatic imagery of these movements.

The journals discussed here are not the only periodicals published under the aegis of Dada and Surrealism, nor are the cities discussed the only ones affected by them.[1] They are, however, some of the most prominent and influential and represent the highlights of the journals in the Mary Reynolds Collection.

Zurich: The Birth of Dada

In February 1916, as World War I raged on, Dada came into being in Zurich in a small tavern on Spiegelstrasse that became known as the Cabaret Voltaire. Founded by the German poet Hugo Ball and his companion, singer Emmy Hennings, Cabaret Voltaire soon attracted artists and writers from across Europe who fled their countries and went to neutral Zurich to escape the war.[2] Ball's cabaret provided ideal conditions for artistic freedom and experimentation and an atmosphere that supported the fomenting of revolt. A press announcement for the cabaret declared:

Cabaret Voltaire. Under this name a group of young artists has formed with the object of becoming a center for artistic entertainment. The Cabaret Voltaire will be run on the principle of daily meetings where visiting artists will perform their music and poetry. The young artists of Zurich are invited to bring along their ideas and contributions.[3]

Jean Arp, Richard Huelsenbeck, Marcel Janco, Sophie Taeuber, and Tristan Tzara were among the artists and poets who responded and began gathering in Ball's Zurich tavern.

From this passionate group, the Dada revolution was conceived and fueled. As German artist Hans Richter recalled, there was a highly charged atmosphere at the cabaret that united this diverse group in a common goal: "It seemed that the very incompatibility of character, origins and attitudes which existed among the Dadaists created the tension which gave, to this fortuitous conjunction of people from all points of the compass, its unified dynamic force."[4]

United in their frustration and disillusionment with the war and their disgust with the culture that allowed it, the Dadaists felt that only insurrection and protest could fully express their rage. "The beginnings of Dada," Tzara remarked, "were not the beginnings of art, but of disgust."[5] As Marcel Janco recalled: "We had lost confidence in our culture. Everything had to be demolished. We would begin again after the *tabula rasa*. At the Cabaret Voltaire we began by shocking the bourgeois, demolishing his idea of art, attacking common sense, public opinion, education, institutions, museums, good taste, in short, the whole prevailing order."[6] Through uproarious evenings filled with noise-music, abstract-poetry readings, and other performances, Dada began to voice its aggressive message. While Dada evenings soon became notorious for insurrection and powerful assaults on art and bourgeois culture, it was through Dada journals that the news of this developing movement reached all corners of Europe and even the United States.

Hugo Ball was also responsible for the first journal directly associated with Dada. Launched in 1916 and named after his Zurich tavern, *Cabaret Voltaire* featured a conservative format with many illustrations and carried contributions by the Dadaists, as well as writings by Futurists and Cubists.[7] Literary works appear in either French or German,

and in the case of a Huelsenbeck and Tzara poem, "DADA," the two languages are interwoven. Through this review, published by the anarchist printer Julius Heuberger, Ball sought to define the activities at the cabaret and to give Dada an identity. In what turned out to be the first and only issue of *Cabaret Voltaire*, he wrote: "It is necessary to clarify the intentions of this cabaret. It is its aim to remind the world that there are people of independent minds—beyond war and nationalism—who live for different ideals."[8]

In 1917, after a year of Dada evenings and Dada mayhem, Cabaret Voltaire was forced to close down, and the Dada group moved their activities to a new gallery on Zurich's Bahnhofstrasse. Shortly after the closing of the cabaret, Ball left Zurich and the Romanian poet Tzara took over Dada's direction. An ambitious and skilled promoter, Tzara began a relentless campaign to spread the ideas of Dada. As Huelsenbeck recalled, as Dada gained momentum, Tzara took on the role of a prophet by bombarding French and Italian artists and writers with letters about Dada activities. "In Tzara's hands," he declared, "Dadaism achieved great triumphs."[9] Irreverent and wildly imaginative, Tzara was to emerge as Dada's potent leader and master strategist.

Attempting to promulgate Dada ideas throughout Europe, Tzara launched the art and literature review *Dada*. Although, at the outset, it was planned that Dada members would take turns editing the review and that an editorial board would be created to make important decisions, Tzara quickly assumed control of the journal. But, as Richter said, in the end no one but Tzara had the talent for the job, and, "everyone was happy to watch such a brilliant editor at work."[10] Appearing in July 1917, the first issue of *Dada*, subtitled *Miscellany of Art and Literature* (fig. 2), featured contributions from members of avant-

garde groups throughout Europe, including Giorgio de Chirico, Robert Delaunay, and Vasily Kandinsky. Marking the magazine's debut, Tzara wrote in the *Zurich Chronicle*, "Mysterious creation! Magic Revolver! The Dada Movement is Launched."[11] Word of Dada quickly spread: Tzara's new review was purchased widely and found its way into every country in Europe, and its international status was established.

While the first two issues of *Dada* (the second appeared in December 1917) followed the structured format of *Cabaret Voltaire*, the third issue of *Dada* (December 1918; fig. 3) was decidedly different and marked significant changes within the Dada movement itself. Issue number 3 violated all the rules and conventions in typography and layout and undermined established notions of order and logic. Printed in newspaper format in both French and German editions, it embodies Dada's celebration of nonsense and chaos with an explosive mixture of manifestos, poetry, and

FIGURE 2

Dada 1, ed. Tristan Tzara (Zurich, July 1917), cover; and *Dada* 2, ed. Tristan Tzara (Zurich, December 1917), cover.

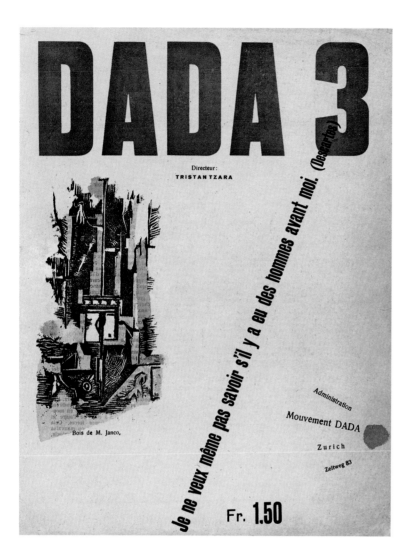

advertisements—all typeset in randomly ordered lettering (fig. 4).

The unconventional and experimental design was matched only by the radical declarations contained within the third issue of *Dada*. Included is Tzara's "Dada Manifesto of 1918," which was read at Meise Hall in Zurich on July 23, 1918, and is perhaps the most important of the Dadaist manifestos. In it Tzara proclaimed:

Dada: the abolition of logic, the dance of the impotents of creation; Dada: abolition of all the social hierarchies and equations set up by our valets to preserve values; Dada: every object, all objects, sentiments and obscurities, phantoms and the precise shock of parallel lines, are weapons in the fight; Dada: abolition of memory; Dada: abolition of archaeology; Dada: abolition of prophets; Dada: abolition of the future; Dada: absolute and unquestionable faith in every god that is the product of spontaneity.[12]

With the third issue of *Dada*, Tzara caught the attention of the European avant-garde and signaled the growth and impact of the movement. Francis Picabia, who was in New

FIGURE 3

Dada 3, ed. Tristan Tzara (Zurich, December 1918), cover.

FIGURE 4

Dada 3, ed. Tristan Tzara (Zurich, December 1918).

York at the time, and Hans Richter were among the figures who, by signing their names to this issue, now aligned themselves with Dada. Picabia praised the issue:

Dada 3 has just arrived. Bravo! This issue is wonderful. It has done me a great deal of good to read in Switzerland, at last, something that is not absolutely stupid. The whole thing is really excellent. The manifesto is the expression of all philosophies that seek truth; when there is no truth there are only conventions.[13]

Dada 4–5 (fig. 5), printed in May 1919 and also known as *Anthologie Dada*, features a cover designed by Arp, a frontispiece by Picabia, and published work by André Breton, Jean Cocteau, and Raymond Radiguet. This issue also includes Tzara's third Dada manifesto and four Dada poems Tzara called "lampisteries." Design experiments continue in this issue with distorted typography, lettering of various sizes and fonts, slanted print, and multicolored paper.

Issue 4–5 of *Dada* was the final one Tzara published in Zurich. With travel possible again at the end of the war, many of the Zurich group returned to their respective countries and Dada activities in Zurich came to an end. With the Dadaists spreading throughout Europe, the impact of the movement had only just begun. Huelsenbeck, Picabia, and Tzara played principal roles in introducing Dada in other cities.

Berlin

Richard Huelsenbeck left Zurich in 1917 for Germany to initiate Dada activities and reconnect with the German avant-garde community that the war had scattered. In Berlin, the devastating years following the war were marked by unrest, rampant political criticism,

and social upheavals. The stage was set for the emergence of a highly aggressive and politically involved Dada group. Dada in Berlin took the form of corrosive manifestos and propaganda, biting satire, large public demonstrations, and overt political activities.

In Berlin, Huelsenbeck met up with artists Johannes Baader, George Grosz, and Raoul Hausmann. While Huelsenbeck contributed greatly to the diffusion of Dadaist

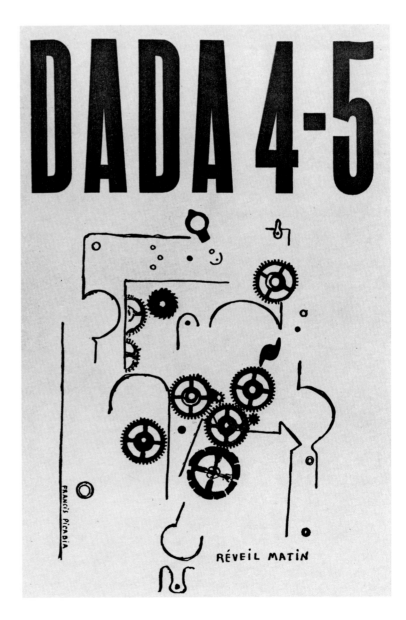

FIGURE 5

Dada, Anthologie Dada 4–5, ed. Tristan Tzara (Zurich, May 1919), cover.

ideas through speeches and manifestos, it was Hausmann who ultimately emerged as one of Germany's most significant Dadaists. A painter, theorist, photographer, and poet, he became an aggressive promoter of Dada in Berlin. To establish his position, in June 1919 he began *Der Dada*, a short-lived yet powerful review that reflects the revolutionary tone of Berlin Dada. Contributions in the first issue by Baader, Hausmann, and Huelsenbeck declare the left-wing political agenda of Berlin Dada, while writings by Tzara and Picabia indicate the alliance between the Berlin group and other Dada centers.

The cover of the first issue of *Der Dada*, which was characteristic of Dada's intentional disorder and unconventional design tactics, features varied type styles and sizes, mathematical abstractions, Hebrew characters, and several nonsense words, all randomly ordered. Among this issue's phonetic poems and several abstract woodcuts is an outrageous—and bogus—announcement that those interested in learning more about Dada could visit the Office of the President of the Republic, where they would be shown Dada artifacts and documents. Such fabrications highlight the Berlin group's interest in satire, and their delight in infiltrating official government activities. The cover of the second issue of *Der Dada* further proclaimed the authority of Dada with declarations that translate as "Dada conquers!" and "Join up with Dada." This issue contains articles by Baader and artist John Heartfield as well as several collages by Hausmann, absurd faked photographs, and satirical cartoons by Grosz.

Issue number 3 of *Der Dada* (April 1920) (fig. 6), is one of the most visually exciting publications generated by the Berlin group. Edited jointly by Grosz, Heartfield, and Hausmann (who signed their names "Groszfield," "Hearthaus," and "Georgemann"), the third issue of *Der Dada* was the most diverse issue yet with several references to Dada in Cologne, Paris, and Zurich. The cover features a chaotic collage by Heartfield of words, letters, and illustrations. The issue includes a drawing by Grosz, two montages by Heartfield, and photographs of the Dadaists, as well as cartoons, poetry, and illustrations.

Known for their rebellious and political tenor, the Berlin Dada group members soon directed their aggressions at one another. With

FIGURE 6

Der Dada 3, eds. George Grosz, John Heartfield, and Raoul Hausmann (Berlin, 1920), cover.

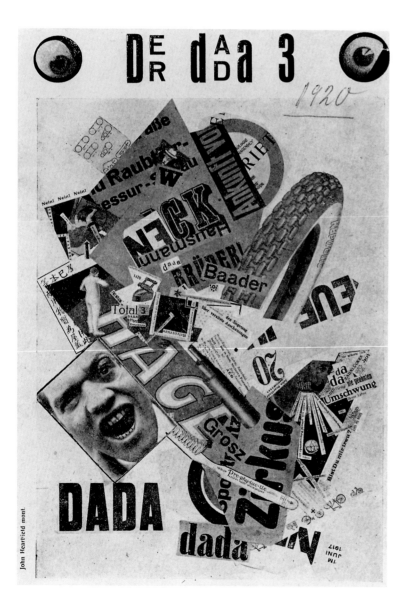

the eruption of many ideological clashes, by 1920 Dada began to decline in Berlin. Although sporadic publications appeared for a few years, by 1923 publishing had ceased, and the Berlin Dadaists began turning their attentions to other activities.

New York

The same year Tzara introduced his review *Dada* in Zurich, related activities took place in New York. Not unlike Zurich, New York had become a refuge for European artists seeking to escape the war. For artists such as Marcel Duchamp and Francis Picabia, the American city presented great potential and artistic opportunity. Soon after arriving there in 1915, Duchamp and Picabia met the American artist Man Ray. By 1916 the three men had become the center of radical antiart activities in New York. While they never officially labeled themselves Dada, never wrote manifestos, and never organized riotous events like their counterparts in Europe, they issued similar challenges to art and culture. As Richter recalled, the origins of Dadaist activities in New York "were different, but its participants were playing essentially the same anti-art tune as we were. The notes may have sounded strange, at first, but the music was the same."[14]

The antiart undercurrents brewing in New York provided an ideal climate for Picabia's provocative journal *391*. Published over a period of seven years, from the time of Dada's birth to the early years of Surrealism, *391* is the longest-running journal in the Mary Reynolds Collection. The magazine first appeared in Barcelona in 1917, and was modeled after the pioneering journal *291*, which was published under the auspices of the photographer and dealer Alfred Stieglitz.[15] Picabia was able to put out four issues of *391* (fig. 7) in Barcelona with the support of some like-

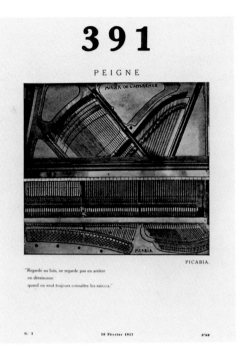

FIGURE 7

391 2, ed. Francis Picabia (Barcelona, February 10, 1917), cover.

minded expatriates and pacifists. Although *391*'s corrosive spirit was only just emerging in these early issues, the anarchic attitude that would later define the magazine and its editor is already apparent. These first issues introduce, for example, a section devoted to a series of bogus news reports. As Gabrielle Buffet-Picabia recalled, this feature began as a mere joke and "quickly degenerated in subsequent issues into a highly aggressive system of assault, defining the militant attitude which became characteristic of *391*."[16] These early issues include literary works by poet Max Jacob, painter Marie Laurencin, and writer Georges Ribemont-Dessaignes, as well as by Picabia, and feature cover illustrations of absurd machines designed by Picabia.

By the time Picabia took *391* to New York at the end of 1917, the magazine had assumed a decidedly assertive and irreverent tone. The New York editions of *391*, issues five through seven, celebrate Picabia's nihilistic

side and his love of provocation and nonsense. Buffet-Picabia had this to say about *391*:

FIGURE 8

The Blind Man 1, eds. Marcel Duchamp, Beatrice Wood, and Henri Pierre Roché (New York, April 10, 1917), cover.

FIGURE 9

The Blind Man 2, eds. Marcel Duchamp, Beatrice Wood, and Henri Pierre Roché (New York, May 1917), pp. 2–3.

It remains a striking testimonial to the revolt of the spirit in defense of its rights, against and in spite of all the world's commonplaces. . . . Without other aim than to have no aim, it imposed itself by the force of its word, of its poetic and plastic inventions, and without premeditated intention it let loose, from one shore of the Atlantic to the other, a wave of negation and revolt which for several years would throw disorder into the minds, acts, works, of men.[17]

Picabia's three New York issues feature contributions by collector Walter Arensberg, painter Albert Gleizes, Max Jacob, and composer Edgar Varèse.

While Picabia was involved primarily with the group of artists surrounding Alfred Stieglitz and with the publication of *391*, Duchamp made connections with Arensberg, through whom he became involved in the Society of Independent Artists. It was this organization, interested in sponsoring jury-free exhibitions, that gave Duchamp the idea for *The Blind Man*—a publication that would invite any writer to print whatever he or she wanted. The inaugural issue (fig. 8), published on April 10, 1917, by Duchamp and writer Henri Pierre Roché, has submissions by poet Mina Loy, Roché, and artist Beatrice Wood. Emphasizing the informal editorial policies and uncertain future of *The Blind Man*, the front cover proclaims, "The second number of The Blind Man will appear as soon as YOU have sent sufficient material for it." When this hastily published first issue came out, the editors realized that they had forgotten to print the address of the magazine on the cover. To remedy this, a rubber stamp was created and used to imprint this information on the front cover of each issue.[18]

Since Duchamp and Roché were not American citizens, and therefore faced possible conflicts with authorities, Beatrice Wood stepped forward to assume responsibility for *The Blind Man*. Because her father subsequently protested her involvement (due to the periodical's content), it was decided that rather than making it available to mainstream audiences through newsstands, *The Blind Man* would be distributed by hand at galleries.[19]

The second issue of *The Blind Man* (fig. 9) came out two months after the first,[20] following the opening of the Society of Independent Artists' 1917 exhibition and the rejection of Duchamp's infamous entry *Fountain*, a urinal that the artist signed with a fictitious name and anonymously submitted as sculpture. This issue features Stieglitz's photograph of *Fountain* and the editorial "The Richard Mutt Case," which discusses the rejection of Duchamp's entry. Also included in this issue were contributions by Arensberg, Buffet-Picabia, Loy, and Picabia, among others.

While *The Blind Man* had caught the attention of the New York art community, a wager brought an early end to the magazine. In a very Dadaist gesture, Picabia and Roché had set up a chess game to decide who would be able to continue publishing his respective magazine. Picabia, playing to defend *391*, was triumphant: Roché and Duchamp were forced to discontinue *The Blind Man*.[21]

Following the early demise of *The Blind Man*, Duchamp launched another short-lived magazine. Edited by Duchamp, Roché, and Wood, *Rongwrong* (May 1917), carries contributions by Duchamp and others within Arensberg's circle, as well as documentation of the moves from Picabia's and Roché's infamous chess game. Duchamp intended the title of the magazine to be *Wrongwrong*, but a printing error transformed it into *Rongwrong*. Since this mistake appealed to Duchamp's interest in chance happenings, he accepted the title.

The appearance of the journal *New York Dada* (April 1921) ironically marked the beginning of the end of Dada in New York. Created by Duchamp and Man Ray, this magazine would be the only New York journal that would claim itself to be Dada. Wishing to incorporate "dada" in the title of this new magazine, Man Ray and Duchamp sought authorization from Tzara for use of the word. In response to their tongue-in-cheek request, Tzara replied, "You ask for authorization to name your periodical Dada. But Dada belongs to everybody."[22] In addition to printing Tzara's response in its entirety, this first and only issue also carried a cover designed by Duchamp, photography by Man Ray, poetry by artist Marsden Hartley, as well as

several illustrations. As with so many self-published artistic journals, this first issue was neither distributed nor sold, but circulated among friends with the hope that it would generate a following. *New York Dada*, however, was unable to ignite any further interest in Dada. By the end of 1921, Dada came to an end in New York and its original nucleus departed for Paris, where Dada was enjoying its final incarnation.

Paris

Although Dada did not reach Paris until 1920, figures in the Parisian literary and artistic world had followed Dada activities either through Tristan Tzara's journal *Dada* or through direct communication with Tzara. Stifled by the restrictions of the war, they were drawn to Dada's revolutionary spirit and nihilistic antics. Writers Louis Aragon, Breton, and Ribemont-Dessaignes had in fact occasionally contributed to *Dada* since 1918, and were eagerly awaiting Tzara's arrival. The voice of Dada would soon be celebrated in Paris.

By 1920 most of the initiators of Dada had arrived in Paris for what was to be the finale of Dada group activities. Arp and Tzara came from Zurich, Man Ray and Picabia from New York, and Max Ernst arrived from Cologne. They were enthusiastically received in Paris by a circle of writers associated with Breton's and Aragon's literary journal *Littérature*. A special Dada issue of *Littérature*, with "Twenty-Three Manifestos of the Dada Movement," soon appeared to celebrate their arrival.[23] Stimulated by Tzara, this newly formed Paris group began issuing Dada manifestos, organizing demonstrations, staging performances, and producing a number of journals.

At the height of Dada activity in Paris, Tzara published two more issues of *Dada*. The first, issue number 6 (February 1920; fig. 10),

also known as *Bulletin Dada*, appeared in large format and contained programs for Dada events, in addition to a series of bewildering poems and outrageous declarations, all presented in the fragmentary typographical style that Tzara had begun experimenting with in Zurich. The many event announcements in this issue reflect the emphasis the Paris group placed on public performance. Contributors to the sixth issue of *Dada* indicate the range of artists who now aligned themselves with the Dadaists: Breton, Duchamp, Eluard, and Picabia are all featured in this issue. The last number of *Dada* (*Dadaphone*) came out in March 1920. This issue features photographs of the Paris Dada members and includes advertisements for other Dada journals and announcements for Dada events, such as exhibitions and a Dadaist ball.[24]

When Picabia joined the Dadaists in Paris in 1919, he too brought his journal with him. In Paris, between the years of 1919 and 1924, he published issues number nine through eighteen of *391* with contributions by such figures as writer Robert Desons, Duchamp, Ernst, artist René Magritte, and composer Erik Satie. After producing four issues, Picabia temporarily suspended *391* in order to publish a new magazine he called *Le Cannibale*. Although more conservative in format than its predecessors, *Le Cannibale* has a provocative spirit and represents the height of Picabia's involvement in the Paris Dada group. After only two issues, (April 1920 and May 1920), however, Picabia abandoned *Le Cannibale* and resumed publication of *391*. For issue number 14, Picabia created one of *391*'s most radical design layouts using a striking combination of font sizes, type styles, and positioning of texts. On the cover, he issued an iconoclastic attack on traditional art. Manipulating the autograph of the classicist artist Jean Auguste Dominique Ingres, Picabia inserted his first name in front of Ingres's. As

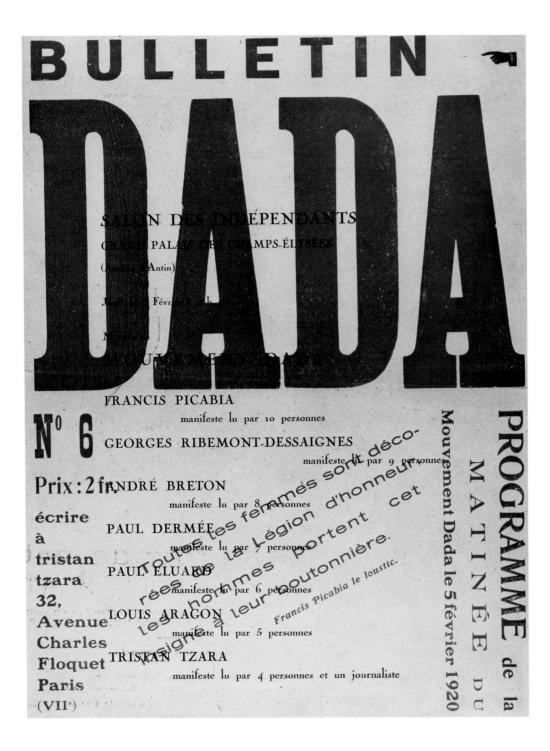

FIGURE 10

Dada 6 (Bulletin Dada), ed. Tristan Tzara (Paris, February 1920), cover.

"Francis Ingres," Picabia not only sought to undermine the position of canonical figures such as Ingres, but he also challenged the value placed on an artist's signature.

The next five issues of Picabia's journal reveal turmoil growing among the Dadaists and suggestions of a shift in Picabia's allegiance from Tzara to Breton. By issue number 16, it was clear that Picabia had left the Dada movement and was focusing on the activities of a newly forming group under the guidance of Breton. In the nineteenth and final issue of *391* (October 1924), he signed off as "Francis Picabia, Stage Manager for André Breton's Surrealism."[25]

The dissension evident in these final issues of *391* reflects the *Littérature* group's growing disillusionment with Tzara and his program. Despite his initial enchantment with Tzara,[26] by 1922 Breton had begun to have misgivings about the Romanian's directives for Dada. His nihilistic antics and antiart

proclamations, exhilarating at first, quickly became tiresome for Paris group members who essentially sought more meaningful and productive responses to their discontent. As he started to assert himself and his own program, Breton began to collide with Tzara. Unable to accommodate Dada to their enterprises, it was not long before Breton and the *Littérature* group denounced Dada and broke away from Tzara. In one issue of *Littérature*, Breton wrote:

Leave everything.
Leave Dada.
Leave your wife, leave your mistress.
Leave your hopes and fears.
Sow your children in the corner of a wood.
Leave the substance for the shadow . . .
Set out on the road.[27]

On another occasion, he declared, "We are subject to a sort of mental mimicry that forbids us to go deeply into anything and makes us consider with hostility what has been dearest to us. To give one's life for an idea, whether it be Dada or the one I am developing at present, would only tend to prove a great intellectual poverty."[28] Soon the world would learn of Breton's developing ideas, and the flag of Surrealism would be raised.

Paris: The Heart of Surrealism

André Breton marked his definitive break with Dada with the release of his "Manifesto of Surrealism" in 1924. This treatise established Breton's position as the leader of Surrealism[29] and earned him the support of many who had previously participated in the Paris Dada group. Aragon, Eluard, and the writers René Crevel and Philippe Soupault and others who aligned themselves with Breton's new movement. In his "Manifesto,"

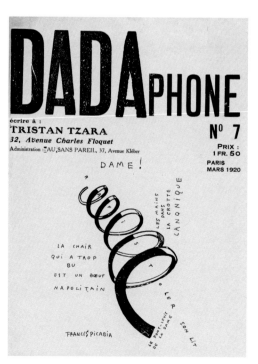

FIGURE 11

Dada 7 (Dadaphone), ed. Tristan Tzara (Paris, March 1920), cover.

Breton officially renounced Dada and gave a formal definition for Surrealism:

SURREALISM, *n*. Psychic automatism in its pure state, by which one proposes to express—verbally, by means of the written word, or in any other manner—the actual functioning of thought. Dictated by thought, in the absence of any control exercised by reason, exempt from any aesthetic or moral concern.

ENCYCLOPEDIA. *Philosophy*. Surrealism is based in the belief in the superior reality of certain forms of previously neglected association, in the omnipotence of dream, in the disinterested play of thought. It tends to ruin once and for all all other psychic mechanisms and to substitute itself for them in solving all the principal problems of life.[30]

With the release of Breton's "Manifesto," Surrealism had a name, a leader, and a direction.

Like Dada, the Surrealist program was marked by pessimism, defiance, and a desire for revolution. Under Breton's leadership, however, Surrealism sought productive, rather than anarchic, responses to the group's convictions. Exploring the subconscious, dream interpretation, and automatic writing were just some of the Surrealists' interests. Not only did such experiments appeal to their revolutionary spirit, but they proved to be remarkable sources of artistic inspiration. Much like Dada, the history of the Surrealist movement can be traced through its many journals and reviews. On December 1, 1924, shortly after he published the first Surrealist Manifesto, Breton released the inaugural issue of *La Révolution surréaliste* (*Surrealist Revolution*).[31] The cover announces the revolutionary agenda of the journal: "It is necessary to start work on a new declaration of the rights of man." With writers Pierre Naville and Benjamin Péret as its first directors, *La Révolution surréaliste* set

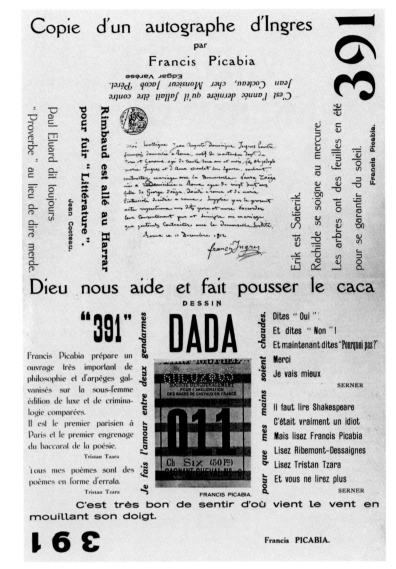

out to explore a range of subversive issues related to the darker sides of man's psyche with features focused on suicide, death, and violence. Modeled after the static format of the conservative scientific review *La Nature*, the Surrealist periodical took a pseudo-scientific approach to such themes: it published an impartial survey on suicide and detached descriptions of violent crime data taken from police reports. The sober and uninspired for-

FIGURE 12

391 14, ed. Francis Picabia (Paris, November 1920), cover.

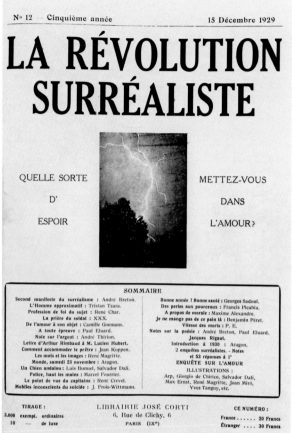

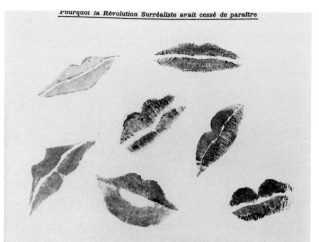

FIGURES 13–14

La Révolution surréaliste 12, ed. André Breton (Paris, December 15, 1929), cover and p. 1.

mat was deceiving, and much to the delight of the Surrealist group, *La Révolution surréaliste* was consistently and incessantly scandalous and revolutionary. Although the focus was on writing, with most pages filled by tightly packed columns of text, the review occasionally made room for a few mediocre reproductions of art, among them works by de Chirico, Ernst, André Masson, and Man Ray.

The third issue of *La Révolution surréaliste* (April 1925), bearing the words "End of the Christian Era" on the cover, strikes a decidedly blasphemous and anticlerical tone with an open letter written to the pope by the writer and actor Antonin Artaud. His "Address to the Pope" expresses the Surrealists' revolt against what they viewed as constraining religious val-

ues: "The world is the soul's abyss, warped Pope, Pope foreign to the soul. Let us swim in our own bodies, leave our souls within our souls; we have no need of your knife-blade of enlightenment."[32] Anticlerical remarks such as this are found throughout *La Revolution surréaliste* and speak of the Surrealist's relentless campaign against oppression and bourgeois morality.

In the fourth issue, André Breton announced that he was taking over *La Révolution surréaliste*. Concerned by some disruptive factions that had developed within the Surrealist group, Breton used this issue to assert his power and restate the principles of Surrealism as he saw them. With each succeeding issue, *La Révolution surréaliste* became more politi-

cal, with articles and declarations that have a pro-Communist slant.

In the eighth issue (December 1926), Eluard revealed the Surrealists' growing fascination with sexual perversion in a piece celebrating the writings of the Marquis de Sade, a man who spent much of his life in prison for his deviant writings about sexual cruelty. According to Eluard, the Marquis "wished to give back to civilized man the strength of his primitive instincts." Breton, Man Ray, and Salvador Dali were as well among those whose writing and imagery exhibited the influence of Sade.

While Surrealist-inspired writings often were the focus of the journal, issue 9–10 of *La Révolution surréaliste* (October 1927) introduces a significant development in Surrealist imagery, with the first publication of the Exquisite Corpse (*Le Cadavre exquis*)—a game greatly enjoyed by the Surrealists that involved folding a sheet of paper so that several people could contribute to the drawing of a figure without seeing the preceding portions. Some of the best results of this game were published in this issue.

The eleventh issue further explores the Surrealists' interest in sex with the publication of the group's "Research into Sexuality," an account of a debate that had taken place during two evenings in January 1928. In this rather frank discussion, the Surrealists had very openly expressed their opinions on several matters related to sex, including a wide range of perversions. The comments of more than a dozen Surrealist artists and writers who participated were printed in this issue.

In the twelfth and final issue of *La Révolution surréaliste* (December 15, 1929; figs. 13–14), Breton published the "Second Surrealist Manifesto." This declaration marks the end of the most cohesive and focused years of Surrealism and signals the beginning of disagreement among its many members. Breton celebrated his faithful supporters and spitefully denounced those members who had defected from his circle and betrayed his doctrine.

The views of this dissident group of Surrealists found a voice in the periodical *Documents*. The inaugural issue, published in April 1929, includes writings by ethnographers, archaeologists, and art historians, with poets Georges Bataille and Michel Leiris emerging as the principal contributors. Employing much of the conventional graphic design and thematic focus of *La Révolution surréaliste*, *Documents*, with an editorial board made up of university professors and other scholars with academic pedigrees, presents a more academic stance. Through *Documents*, these dissidents attempted to define their directives for the future of the movement and sought to undermine Breton's claim on Surrealism. As with so many journals of the time, however, by the end of 1930, after fifteen issues had been published, the editors turned their attentions to other projects and *Documents* ceased to appear.

Breton's successor to *La Révolution surréaliste* was the more politically engaged journal *Le Surréalisme au service de la Révolution*. Although this journal appeared only sporadically between 1930 and 1933, it made a lasting mark on Surrealist imagery. Like its predecessor, it sought to counter oppression of individual liberties with writing and imagery that celebrate blasphemy, sadism, and sexual expression. In this first issue, Dali, who had just moved to Paris and joined the Surrealists in 1929, declared, "It must be stated once and for all to art critics, artists, etc., that they can expect from the new Surrealist images only deception, a bad impression and repulsion."[33] In subsequent issues, the Surrealists would make good on this promise with increasingly blasphemous and deviant writings. Horrific texts

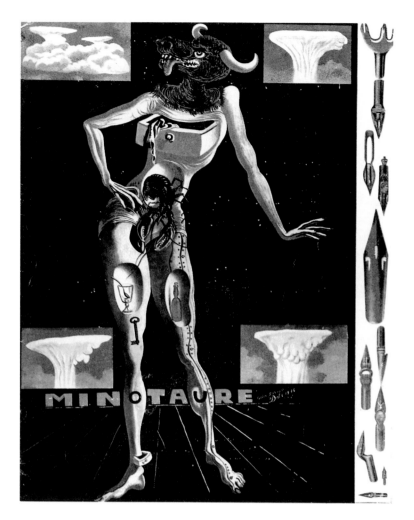

FIGURE 15

Minotaure 8, ed.
Albert Skira (Paris,
June 1936), cover.

magazine would cover all of Breton's inter-ests—poetry, philosophy, archaeology, psy-choanalysis, and cinema. Skira's only restric-tion was that Breton would not be allowed to use the magazine to express his social and political views. Although the extravagance of *Minotaure* would be unlike any of the raw revolutionary periodicals conceived by the Sur-realists, Breton, with *Le Surréalism* faltering and his personal finances in a desperate state, eventually lent his support to Skira. In the sixth and final issue of *Le Surréalisme* (May 1933), Breton published a full-page advertisement announcing the inaugural issue of *Minotaure*.[34]

In February 1933, four months before the first issue appeared, Skira had ambitious hopes for his new journal of contemporary art:

Minotaure will endeavor, of set purpose, to single out,bring together and sum up the elements which have constituted the spirit of the modern move-ment, in order to extend its sway and impact; and it will endeavor, by way of an attempted refocus-ing of an encyclopedic character, to disencumber the artistic terrain in order to restore to art in movement its universal scope.[35]

on suicide and murder, bizarre accounts of the macabre, and a series of explorations of the work of Sade are just some of the features that run alongside the journal's aggressive political assertions.

Perhaps due to the outrageous and mili-tant tone of this journal, after only six issues, sales dropped drastically and lack of financial backing forced Breton to cease publication in 1933. At this same time, the publisher Albert Skira had contacted Breton about a new jour-nal, which he promised would be the most luxurious art and literary review the Surrealists had seen, featuring a slick format with many color illustrations. He promised that this

With eight hundred subscribers already in hand, in June 1933 the first two numbers of *Minotaure* appeared. With cover designs by Pablo Picasso and Gaston Louis Roux, respec-tively, these inaugural issues, expertly printed and designed, assert *Minotaure*'s claim as the authority on the "spirit of the modern move-ment." A sumptuous review, *Minotaure* is indeed the most lavish journal in the Mary Reynolds Collection and was the most effec-tive vehicle for promoting Surrealist imagery.

Over the next six years, twelve additional numbers (figs. 1, 15–16) were released with rich coverage not only of the Surrealists, but of many other emerging artists as well. Through *Minotaure*, many little-known fig-

ures such as Hans Bellmer, Victor Brauner, Paul Delvaux, Alberto Giacometti, and Roberto Matta came to the attention of the art world. With sensational covers, high-quality photography, and the frequent use of color, *Minotaure* brought such artists' work to life like no other magazine had. It was *Minotaure* that first reproduced the sculpture of Picasso, as well as some of the most provocative of Dali's images. For Dali, in particular, *Minotaure* provided a remarkable forum: his writing appears in eight issues.

Breton, Eluard, and writer Maurice Heine were among Skira's other most valued contributors. Not only did this group offer editorial and at times fundraising assistance, they also regularly contributed features to *Minotaure*. Breton's theoretical writings, Eluard's poetry, and Heine's articles about book illustration and the works of Sade all added to its eclectic and animated contents.

In addition to broad coverage of visual art, poetry, and cinema, *Minotaure* reported on new technologies and advances in the human sciences. As Skira had so ambitiously intended, for a brief time, *Minotaure* was indeed a remarkable barometer of contemporary developments in all cultural activities. Although not exclusively Surrealist in orientation, it was faithful to the Surrealist spirit, and, with its appeal to the mainstream art public, gained wider recognition for the movement. By 1939, however, with Europe in a deep economic slump and on the verge of World War II, Skira was no longer able to afford to continue his deluxe magazine. In February 1939 the final issue appeared.

Surrealism in New York

The outbreak of World War II brought many of the Surrealists to New York: Dali, Man Ray, Matta, and Yves Tanguy had all arrived

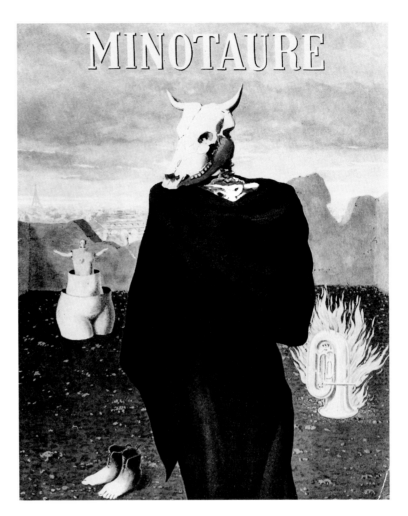

by 1940. With several European reviews suspended or increasingly inaccessible due to the war, the Surrealists in New York immediately attempted new publications. In September 1940, the first issue of *View* magazine, edited by Charles Henri Ford, was published. Thirty-one subsequent issues appeared between 1940 and 1947. *View* offered coverage of art, literature, music, and cinema—anything that was new and modern, as one of its slogans read: "You can't be modern and not read *View*." While the scope of this journal was broad, at times *View* gave particular attention to the activities of the Surrealists: Duchamp was on the advisory board, Mary Reynolds was listed

FIGURE 16
Minotaure 10, ed. Albert Skira (Paris, Winter 1937), cover.

FIGURE 17

VVV 2–3, ed. David
Hare (New York,
March 1943), cover.

as the journal's Paris Representative, and issue number 7–8 of *View* (October-November 1941) was dedicated to Surrealism, featuring the art of Artaud, Victor Brauner, Leonora Carrington, Duchamp, and Masson.

Another New York journal that represented Surrealism was *VVV*, published by the young American sculptor David Hare. With Breton, Ernst, and Duchamp as editorial advisors, *VVV* gave exiled Surrealist writers and artists great exposure in the United States. Modeled on *Minotaure* and more substantial than *View*, *VVV*'s three issues feature "Poetry, plastic arts, anthropology, sociology, psychology." The first issue (October 1942) has a cover design by Ernst and includes writing by Breton. Reflecting new connections within the New York art community, this issue also features contributions by artist Robert Motherwell and critic Harold Rosenberg. The next issue, a double number (March 1943; fig. 17), has front and back covers by Duchamp. The front cover is an anonymous etching representing an allegory of death that Duchamp appropriated. The back cover features the shape of a woman's profile cut out of the cover with a piece of chicken wire inserted in the opening. The final issue of *VVV* (February 1944) is similarly creative and dynamic. With a bold cover designed by Matta, this issue features many fold-out pages of varying sizes, a combination of different papers, and many color images.

In addition to extending the life of the Surrealist movement, American reviews such as *View* and *VVV* provided a forum for communication between the Surrealists and a growing number of emerging American artists. For artists who later would make up the Abstract Expressionist group, the Surrealists were a significant and liberating influence. While Surrealism's potency was in decline by this time, artists of the next generation would continue to explore its tenets.

Although neither Dada nor Surrealism revolutionized society as profoundly as their proponents had hoped, they left an indelible mark on art and writing. The iconoclastic impulses of these movements remain rich sources of artistic inspiration. The remarkable journals they generated preserve a detailed record of the revolutionary atmosphere in which they were conceived. Through their journals, the Dadaists and Surrealists defined and broadcast their views of the world, and expressed their hopes to transform and liberate art and culture. For admirers of the rich and revolutionary ideas of these movements, these journals offer unique insights into the minds of their creators.

Hans Bellmer in The Art Institute of Chicago: The Wandering Libido and the Hysterical Body

SUE TAYLOR

Department of Art History
The University of Chicago

In December 1934, there appeared in the Surrealist journal *Minotaure* a two-page spread introducing French readers to the erotic imagination of the German artist Hans Bellmer (fig. 2). Eighteen photographs Bellmer had taken of a life-size, female mannequin are grouped symmetrically around the title "Doll: Variations on the Montage of an Articulated Minor." The images show Bellmer's assemblage, made of wood, flax fiber, plaster, and glue, under construction in his studio or arrayed on a bare mattress or lacy cloth. Seductive props sometimes accompany the doll—a black veil, eyelet undergarments, an artificial rose. Naked or, in one case, wearing only a cotton undershirt, the armless doll is variously presented as a skeletal automaton, a coy adolescent, or an abject pile of discombobulated parts. In one unusual image, the artist himself poses next to his standing sculpture, his human presence rendered ghostly through double exposure. Here Bellmer's own body seems to dematerialize as his mechanical girl, wigged, with glass eyes, wool beret, sagging hose, and a single shoe, takes on a disturbing reality.

The Surrealist fascination with automata, especially the uncanny dread produced by their dubious animate/inanimate status, prepared the way for the enthusiastic reception in France of Bellmer's doll. His stated preoccupation with little girls as subjects for his art, moreover, coincided with the Surrealist ideal-

ization of the *femme-enfant*, a muse whose association with dual realms of alterity, femininity and childhood, inspired male artists in their self-styled revolt against the forces of the rational. But these dovetailing concerns—of the artist-intellectuals grouped around André Breton in Paris, and of the isolated Bellmer, working in virtual seclusion in a suburb of Berlin—were arrived at separately. Bellmer's doll, the first sculptural construction of an erstwhile graphic designer, developed out of a series of three now legendary events in his personal life: the reappearance in his family of a beautiful teenage cousin, Ursula Naguschewski, who moved to Berlin from Kassel in 1932; his attendance at a performance of Jacques Offenbach's *Tales of Hoffmann*, in which the protagonist falls tragically in love with the lifelike automaton Olympia; and a shipment from his mother of a box of old toys that had belonged to him as a boy. Overwhelmed with nostalgia and impossible longing, Bellmer acquired from these incidents a need, in his words, "to construct an artificial girl with anatomical possibilities ... capable of re-creating the heights of passion even to inventing new desires."[1]

While the child in her anachronistic costume is by now a familiar motif in Bellmer's repertory, and the sexual symbolism of the smokestack is obvious, what can be the meaning of hands with too many fingers and mysterious brown eyes that gaze out from their palms?

FIGURE 1

Hans Bellmer (German, 1902–1975). *Child and Seeing Hands*, c. 1950. Pen and brown ink, gouache, and watercolor on paper; 23.8 x 28.5 cm. The Art Institute of Chicago, Mr. and Mrs. Joseph R. Shapiro Collection (1992.196).

FIGURE 2
Hans Bellmer.
"Poupée: Variations
sur le montage d'une
mineure articulée,"
Minotaure 6 (Winter
1934–35), pp. 30–31.
The Art Institute of
Chicago, Mary
Reynolds Collection.

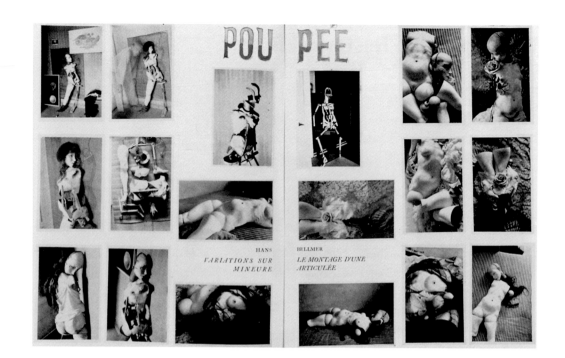

Bellmer celebrated his invention of the doll in a delirious essay, "Memories of the Doll Theme" (1934): "It was worth all my obsessive efforts," he wrote, "when, amid the smell of glue and wet plaster, the essence of all that is impressive would take shape and become a real object to be possessed."[2] In their explicit sexual implications, the images of "young maidens" he put forth in this essay depart dramatically from the ideal of the innocent *femme-enfant*. Bellmer imagined little girls engaged in perverse games, playing doctor in the attic; he meditated lasciviously on "their bowed and knock-kneed legs" and "the casual quiver of their pink pleats"; and he despaired "that this pink region," like the pleasures of childhood itself enjoyed in the maternal plenitude of a "miraculous garden," was forever beyond him. In closing his essay, Bellmer took revenge on little girls for their unavailability, envisioning the manufacture of the doll in their image, which he probed "with aggressive fingers" and "captured rapaciously by [his] conscious gaze."

The pink pleats, Bellmer's poetic metaphor for female genitals, would become a recurring motif in his drawings and prints, and the female body itself, with the exception of a small number of portraits of friends,[3] remained Bellmer's sole artistic subject—to the point of obsession. A fantastic drawing in the Art Institute's collection, executed in white gouache on black paper in 1936, is an early indication of the fetishistic metamorphoses of the female body Bellmer produced throughout his career (fig. 3). Here pleated skirts swirl around a confusion of anatomical fragments: two or more bodies seem to be suspended from columns or to float in air; a breast, buttocks, legs in striped hose, and high-heeled boots all blend with phallic forms in a grotesque turmoil. At the lower right, a girl's face emerges in profile from a deluge of flowing lines, which double as hair and as a watery cascade emanating from a mountainous landscape in the distant background. This cursory landscape and the curious detail of a rearing horse at the right of Bellmer's

drawing suggest his close study of Italian and Northern Renaissance graphics in Berlin's Kaiser Friedrich Museum;[4] but, even if this image originated in some figure of Saint George rescuing his princess, Bellmer's fascination with sexual themes, as always, renders the subject marginal.

He presented his essay "Memories of the Doll Theme" in *Die Puppe* (*The Doll*), a booklet printed in a very small edition at the artist's expense by his friend Thomas Eckstein in Karlsruhe, with ten photographs of the doll tipped in by hand, as in a family album.[5] The photographs Bellmer selected for inclusion in this precious *livre d'artiste* were among those later published as "Variations on an Articulated Minor," beginning with the gaunt framework of the doll in its initial stages of construction and ending with a still-life arrangement of detached plaster legs surrounded by white undergarments, a rose, and a single high-heeled pump. The tiny size of the edition and of the book itself lends a secretive quality to Bellmer's project, which was possibly a function of necessity in Germany, where the Nazis had assumed power and were increasingly suspicious of modern artists. Not long after his *Minotaure* debut, Bellmer visited Paris, gaining an introduction to Breton; on his return to Berlin, he began to collaborate through the mail with the Surrealist writer Robert Valençay on an exacting French translation of "Memories of the Doll Theme." In 1936 *La Poupée*, a limited French edition of *Die Puppe*, was issued by Guy Lévis-Mano in Paris (fig. 4); a copy of this book is preserved in the Art Institute's Mary Reynolds Collection.

As in the German edition, Bellmer reproduced his essay on delicate pink pages, with a linocut of the doll's torso illustrating a rotating "peep-show" mechanism he planned to incorporate in the belly of the actual doll, operated by pressing the figure's left nipple (fig. 5).

Although this plan was never realized, the voyeuristic drive that propelled it survives in the linocut, where an inquisitive, disembodied eye peers through the doll's navel, and a dark hand pokes the doll's breast. This image of male sexual curiosity and domination is in a sense emblematic of Bellmer's entire oeuvre: the hapless female body, deprived of head and limbs, is scrutinized and manipulated, and its

FIGURE 3

Hans Bellmer. *Untitled*, 1936. Pen and white gouache on black wove paper; 24.9 x 15.9 cm. The Art Institute of Chicago, Mr. and Mrs. Joseph R. Shapiro Collection (1992.197).

inner workings exposed in a cut-away view. "Lay bare suppressed girlish thoughts," the artist instructed himself, "ideally through the navel, visible as a colorful panorama electrically illuminated deep in the stomach."[6] And just as Bellmer revisited an infantile world in "Memories of the Doll Theme"—one of magic kits, Easter eggs, puppets, and cat's-eye marbles —tinged with sexuality, in this linocut he seems to have posed quintessential childish questions: "How are girls different?" and "Where do I come from?"[7]

In order better to manipulate the doll, Bellmer developed a second version, which he organized around the principle of the ball joint. Inspired by a pair of sixteenth-century articulated wooden dolls in the Kaiser Friedrich Museum,[8] he produced a spherical belly for the new doll, around which he could arrange a number of parts in various combinations: four legs, four round stylized breasts, an upper torso, three pelvises, a pair of arms, and the recycled head and hand from the first doll. From 1935 through 1938, this second figure, in its numerous permutations, appeared in over one hundred photographs, many hand-colored to heighten their emotive impact. Unlike the photographs of the first doll, which documented the construction of the object or treated it as still life, Bellmer's photographs of the ball-jointed doll establish sinister narrative tableaus, with new emphasis on the doll's environment: outside the studio, the doll becomes a dramatic character, often the victim of an unseen tormentor, in domestic interiors, basement, hayloft, or forest.

In one image, for example, the doll is a tragic amputee, armless and tied on a shadowy stairway with frayed twine (fig. 7). With a second (reversed) pelvis substituting for its chest, the doll is given buttocks for breasts, and these seem incongruously large, considering the undeveloped pudenda and the juvenile hair-bow. The doll's left leg is bound at the knee, while the right thigh ends abruptly in midair, exposing a hollow core. All is passive, inert: one hand lies limply against the banister, and a blank, unseeing eye suggests a loss of consciousness. Who, one wonders, is responsible for the naked and abject condition of the doll?[9] While the brutality implicit in such images is often elided in the literature, Bellmer's biographer, Peter Webb, detected "intimations of rape" in another, singularly bizarre photograph of the doll, partly lying, partly seated, on a rumpled bed, and half dressed in a man's trousers with the belt and fly provocatively open (fig. 8).[10] Here the doll is composed of two sets of hips and legs—with feet shod in shiny Mary Janes—around the central ball joint of the exposed abdomen. Some kind of sexual struggle seems underway, yet the remains of a meal on a table next to the bed give a sense of satiation, and perhaps the pants have been loosened merely to ease the pressure on a bulging stomach.

Such ambiguous readings are not easily resolved, and in fact the power of these photographs often resides in the coexistence of the perverse and the banal. The peculiar combination of male and female in the postprandial image has prompted speculations about hermaphrodism, while Bellmer scholar Therese Lichtenstein noticed "a highly complex, contradictory dynamic in which issues of individuation, separation, and symbiotic union are played out in terms of a kind of identity crisis."[11] The scene has the quality of nightmare: with its eerie shadows, disheveled bed linens, vague domesticity, and aura of voyeurism, it could be said to stage a troubled fantasy of the primal scene. Indeed, the uncertainty of the child about the possibly violent "struggle" of his parents in bed is echoed in the confusion aroused by this photograph. The elevated point of view has a destabilizing effect,

FIGURE 4

Hans Bellmer. *La Poupée* (*The Doll*). Paris: Editions G.L.M., 1936. Translated from the German by Robert Valençay. Printed on pink paper, with ten original photographs tipped in on tan paper, ed. 36/100; 16.7 x 12.8 x 0.5 cm. The Art Institute of Chicago, Mary Reynolds Collection.

LEFT FIGURE 6

Hans Bellmer and Paul Eluard. *Les Jeux de la poupée* (*The Games of the Doll*). Paris: Les Editions premières, 1949. Fifteen hand-colored black-and-white photographs by Bellmer tipped in, fourteen verses by Eluard. Black construction-paper cover over board with pink construction-paper belly band, ed. 118/136; 25 x 19.5 x 1.5 cm. The Art Institute of Chicago, Mary Reynolds Collection.

ABOVE FIGURE 5

Hans Bellmer. *La Poupée* (*The Doll*), detail. Paris: Editions G.L.M., 1936. Linocut on pink paper; 16.7 x 12.8 cm. The Art Institute of Chicago, Mary Reynolds Collection.

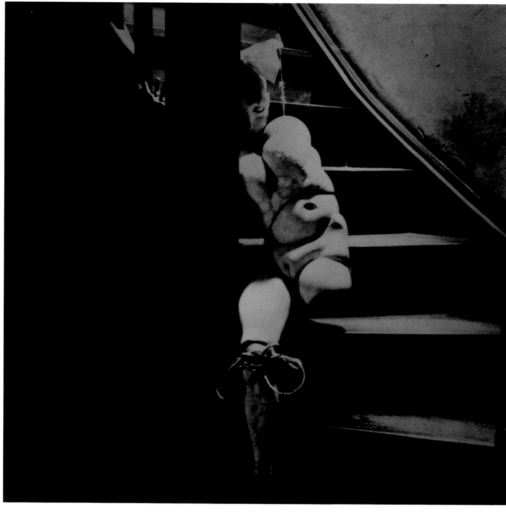

tipping the floor toward the picture plane so that food, figure, and mattress seem about to slide off to the lower left. The feeling of vertigo is exacerbated by the insistent downward-left direction of the stripes on the bed covers and tablecloth, the knives on the empty plate, and the fringed edges of the carpets.

In late 1935 or early 1936, Bellmer sent a number of the photographs of the second doll to Paris, where they were received by Breton, Paul Eluard, Henri Parisot, and Valençay, and soon appeared in *Minotaure* and in an issue of *Cahiers d'art* devoted to the Surrealist object.[12] When the artist moved from Berlin to Paris,

following the death of his wife in February 1938, Eluard selected fourteen of the photographs, including the two discussed above, and "illustrated" each of them with a short poem.[13] These images and their corresponding verses were to be published by Christian Zervos in 1939, but when war with Germany broke out, the project collapsed;[14] Bellmer managed only to produce, on his own, a tiny edition of the book, *Poupée II*. Ten years passed before the full collaborative work was published, by Editions Premières in Paris, as *Les Jeux de la poupée* (*The Games of the Doll*). The Art Institute owns number 118 in this small

edition of 136 (fig. 6).[15] On the black construction-paper cover of the book, the artist affixed an image of the second doll, reduced to its spherical belly radiating two pelvises; Bellmer cut the image out of a black-and-white photograph and hand-colored it in yellow and purple. A pink band wraps around the cover, indicating the book's authors and title.

Just as he had included "Memories of the Doll Theme" with photographs of his first doll in both the German and French editions of *The Doll*, Bellmer provided an introductory essay, "Notes on the Subject of the Ball Joint," for *Les Jeux de la poupée*. He had written the latter essay—bizarre and convoluted, in a pseudoscientific tone—in German in 1938, and revised it slightly while working with Georges Hugnet to translate it into French in 1946.[16] Hugnet, a Surrealist artist and poet, also had a bookbinding studio in Paris from 1934 to 1940; during that time, he and Bellmer had collaborated on yet another *livre d'artiste* in the Mary Reynolds Collection, the exquisite little *Oeillades ciselées en branche* (*Glances Cut on the Branch*) (Paris, 1939), with its distinctive pink cover wrapped in a white paper doily (fig. 9). Adding to the object's synaesthetic allure, the first thirty copies of the edi-

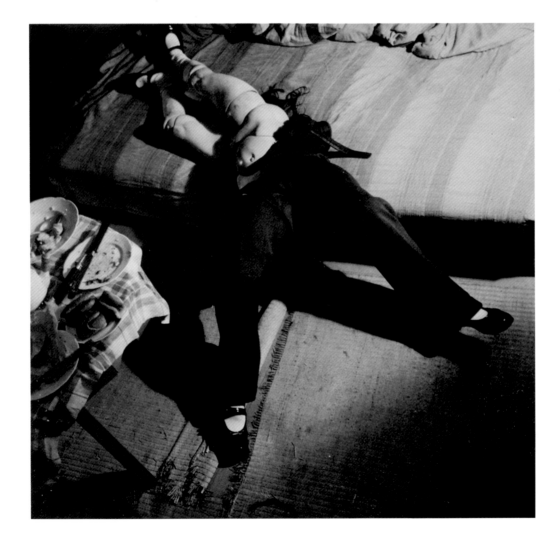

FIGURE 8

Hans Bellmer. Plate 9 of *Les Jeux de la poupée* (*The Games of the Doll*). Paris: Les Editions premières, 1949. Hand-colored black-and-white photograph. The Art Institute of Chicago, Mary Reynolds Collection.

tion of two hundred and thirty were impregnated with perfume.[17] To Hugnet's handwritten, poetic text adulating pubescent females, Bellmer juxtaposed twenty-five drawings of little girls at play, reproduced in heliogravure in pink, brown, and olive green.

The very daintiness of this presentation, together with Bellmer's delicate draftsmanship, belies the indecent aspects of the book's content. In certain illustrations, girls are shown innocently engaged, with hoops and diabolos, riding on scooters, in pleated skirts or jumpers; in some instances, however, they are naked, with articulated, doll-like bodies, or are clad in seductive undergarments and high-heeled boots. Projecting his own prurience onto his subjects, Bellmer included one drawing of a girl, legs lifted, examining her genitals in an ornate mirror. There is also something suggestive, moreover, about the book's peculiar title. The original French phrase, *oeillades ciselées en branche*, was borrowed from a sign in a market offering bunches of grapes still attached to branches from the vine.[18] Bellmer

and Hugnet responded to the double meaning of *oeillades*—"bunches" and "glances"—especially since an *oeillade* can be an ogling glance, a leer. Embedded in this punning, found phrase are implications of the desiring male gaze and perhaps, too, wishes to "harvest" the budding girlhood sexuality that is the theme of the book.

One of the stranger and more detailed illustrations to *Oeillades ciselées en branche* is key, when brought into association with a related passage in "Notes on the Subject of the Ball Joint" mentioned above, to Bellmer's idiosyncratic conceptions of body image and libidinal experience. On page 28 of the book, an articulated female doll, naked except for a filmy blouse, thigh-high stocking, and lace-up boot, is shown seated at a round table, holding an apple aloft in one hand (fig. 10). The curvaceous form is hardly that of child, but neither the face nor the large hair-bow seem to belong to a mature woman. An arm, leg, and breast are missing from the figure; still-life objects serve as their surrogates: a baguette substitutes for the arm, the table leg wears the matching boot, a milk pitcher doubles as a breast. Bellmer depicted the body as an amalgamation of the organic and inorganic, transgressing its normative limits to incorporate aspects of its environment. He fantasized the body as a series of shifting, interchangeable erogenous zones, subject to the forces of psychic repression in what he termed "the physical unconscious." Introducing this idea in "Notes on the Subject of the Ball Joint," he grouped his speculations around the image of a little girl sitting at a table:

How to describe, one will wonder, the physical consciousness of a seated little girl who, placing all emphasis on her raised shoulder and stretching her arm lazily on the table, hides her chin between the muscle of her upper arm and her chest, in

FIGURE 9

Hans Bellmer and Georges Hugnet. *Oeillades ciselées en branche (Glances Cut on the Branch)*. Paris: Editions Jeanne Bucher, 1939. Text by Hugnet with twenty-five illustrations by Bellmer. Printed in heliogravure and bound with pink paper and a white paper doily, ed. 93/230; 13.5 x 10.8 x 0.6 cm. The Art Institute of Chicago, Mary Reynolds Collection.

such a way that the pressure of the arm . . . flows from her armpit in a linear relaxation, slips further, passing the elbow, on to the slightly bent wrist, hardly noticing the slope of the back of the sleeping hand before terminating under the tip of her index finger resting on the table, in the accent of a little grain of sugar.[19]

Bellmer felt he must understand why certain parts of the body were absent from his imaginary girl's awareness. Using psychoanalytic terms such as "condensation" and "displacement" to develop his theory, he proposed that, in the body's sense of itself, various parts can stand for or symbolize others. He reasoned that, because amputees retain awareness of their missing limbs, the images of the absent parts may be taken over by other areas of the body. The substitution of body parts one for another was of course the provocative technique underlying the permutations of his second doll, and here Bellmer ascribed the rationale for his method to the female figure itself: "It is in this way," he explained, "that the pose of the little girl must be understood; composing herself around the center 'armpit,' she is obliged to divert consciousness from the center 'sex,' that is to say, from that which it was painfully forbidden or inopportune to gratify." Determined, as always, to investigate the female body, Bellmer believed he was analyzing its psychosexual dimensions. In his attempts to do this, he relied on the writings of Freud, familiar to all the Surrealists, and on the clinical studies of the Austrian psychiatrist Paul Schilder (1886–1940).[20]

Freud's model of the mobility of the libido provided the basis for Bellmer's theorizing about erotic feeling, which he projected onto the image of a "seated little girl." Freud observed in a lecture that "sexual impulse-excitations are exceptionally plastic":

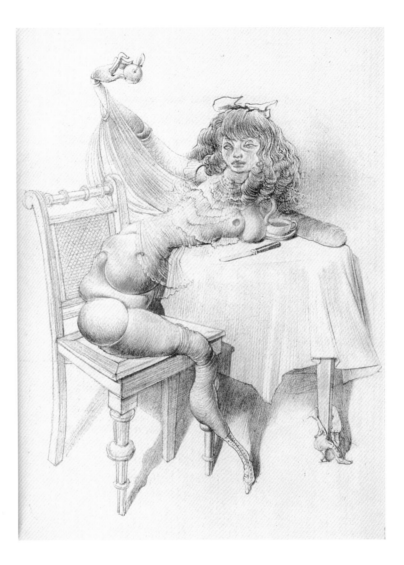

One of them can step in in place of another; if satisfaction of one is denied in reality, satisfaction of another can offer full recompense. They are related to one another like a network of intercommunicating channels filled with fluid, and this in spite of their subordination to the primacy of the genitals—a state of affairs that is not at all easily combined in a single picture.[21]

This capacity for displacement and the acceptance of surrogates, Freud stated, enables individuals to maintain health in the face of frustration.[22] As a creator of surrogates himself,

FIGURE 10

Hans Bellmer. Illustration for *Oeillades ciselées en branche (Glances Cut on the Branch).* Paris: Editions Jeanne Bucher, 1939. Heliogravure; 13.5 x 10.8 cm. The Art Institute of Chicago, Mary Reynolds Collection.

inventor of virtual girls, Bellmer comprehended this capacity but located his own wandering libido in a female other. Schilder, too, remarked on the fluid *Körperschema*, or body image; and Lichtenstein has shown the importance of his book *The Image and Appearance of the Human Body* (1935) for Bellmer's thinking in this regard.[23] Intensely interested in the relationship between body and mind, the artist was attracted to the psychiatrist's stress on the inseparability of the two: early in his career, Schilder had concluded "that the laws of the psyche and the laws of the organism are identical"; he could not, therefore, describe "the symbolic interchange of organs by transposition" in the mental realm without adding that "there is no psychic experience which is not reflected in the motility and in the vasomotor functions of the body."[24]

This emphasis led eventually to Bellmer's presentation of his theory of a "physical uncon-

scious" in his 1957 book *Petite Anatomie de l'inconscient physique ou l'anatomie de l'image* (*Little Anatomy of the Physical Unconscious or the Anatomy of the Image*) in which he revived his description of the seated little girl and other portions of "Notes on the Subject of the Ball Joint."[25] He depended for a number of his insights on Schilder's clinical investigations of his patients' perceptions of their bodies, his work with amputees and their phantom limbs, and with hemiplegics who suffered paralysis of arms or legs due to strokes or brain lesions.[26] Schilder studied how impairment of the brain affects the ability to recognize or control parts of the body, and how, in some cases, inanimate objects such as clothes and tools may be incorporated into the body-image—as seen in Bellmer's illustration of the seated little girl whose doll-like body is additionally composed of a loaf of bread, milk jug, and table leg (fig. 10).

"One of the most important characteristics of psychic life," the psychiatrist asserted, "is the tendency to multiply images and to vary them with every multiplication." He invoked as an example the universal delight in imagining figures like Indian gods and goddesses with their many arms and legs.[27] Bellmer's myriad variations on the body of the doll might be taken as evidence of this psychic tendency expressed in the realm of sculpture; his later graphic work pushes this trend to an even greater extreme with the proliferation of limbs in his cephalopods—female heads with legs, often in stockings and heels—or with the octopuslike creature depicted in the Art Institute's *Articulated Hands* of 1954 (fig. 11). In this color lithograph, Bellmer conjured a figure made up of no fewer than seven arms and eight hands, the latter assuming affected positions with lifted pinkies and long, pointed nails. Remembering the sixteenth-century wooden dolls that spurred his obsession with the articulated joint (even their wrists and ankles, fingers and toes were adjustable), the artist treated each knuckle as a glowing ball joint. The hands seem thus bejeweled but also bony and strangely skeletal.

In the Art Institute's delicate pencil study of 1951 for another (unpublished) lithograph, *Articulated Hand*, Bellmer presented a hand that, because it also reads as a monstrous seated figure, assumes a gigantic scale (fig. 12). Indeed, the artist's inventive power is such that the hand, with its bent wrist and clawlike thumbnail, becomes on closer inspection a grouping of at least three figures—all headless, wrapped like mummies, with their exposed ball-joint bellies and knees emerging from the great hand's knuckles. Finger-legs extend gracefully en pointe, but a sense of struggle pervades the fused torsos that form the back of the hand and imply a face, with nipples and navel doubling as wary eyes and a tiny pursed mouth.

Hands, eroticized and multiplied, appeared early in Bellmer's drawings as a favored motif, where finely rendered fingers touch ripe fruits and vaginal-looking orchids, or are interlaced by a winding snake.[28] Suggestive but ultimately conventional studies, these images gave way in the artist's oeuvre to more troubled and complex treatments of hands growing out of a human head, or altogether stripped of flesh and deathly.[29]

A series of untitled and undated photographs of real hands inextricably intertwined in sensuous embraces points again to Bellmer's interest in Schilder's researches into disturbances of bodily awareness.[30] Describing cases of agnosia and apraxia (inability to recognize and to move, respectively) of the fingers, the psychiatrist referred to the "Japanese illusion" to demonstrate the occurrence of agnosia even in the normally functioning brain and to show that optical stimuli contribute to, but do not fully determine, body image:

FIGURE 12

Hans Bellmer. *Untitled*, 1951. Graphite on cream wove paper; 38.1 x 28.1 cm. The Art Institute of Chicago, Lindy and Edwin A. Bergman Collection (101.1991).

I have often mentioned [Schilder explained] the so-called Japanese illusion. When one crosses one elbow above the other and intertwines the fingers and thumbs around the hands again, one has before the eye another complicated picture of the fingers. If the subject is now ordered by pointing to move a specific finger, he is very often unable to do so. He moves either the next finger or the finger of the opposite hand. . . . Mistakes with the left hand are more common than with the right hand. The difficulties with the third and fourth fingers are greater than with the other fingers.[31]

According to Schilder, "the body-image has to be built up again [in this exercise] when by the double-twisting the optic and tactile sensations have lost their clear structure." Bellmer's graphic and photographic depictions of hands duplicate the kind of confusion produced in Schilder's finger demonstration, with the viewer trying to negotiate the formal boundaries of each hand and its relationship to the image as a whole. As in the drawing and description of the seated little girl, Bellmer's aim here was to illustrate that body image is complexly constructed or experienced—and mutable.

An astonishing pair of hands made of pink bricks hovers like a giant butterfly in a beautiful ink-and-gouache drawing titled *Child and Seeing Hands*, made about 1950 (fig. 1). Surrealist in both iconography and technique, this drawing from the Art Institute's collection is an example of the decalcomania process Bellmer had learned from Oscar Dominguez in 1940. In this technique, the medium (ink, watercolor, or paint) is applied to a sheet of paper; the sheet is covered with another piece of paper, and the two are pressed or rubbed together. When the second sheet is pulled away, a textured surface is revealed, full of chance effects in which the artist can discover and develop serendipitous images,

Rorschach-style. Upon the rich, spongy field Bellmer created by these means for *Child and Seeing Hands*, a girl in a pleated white dress, striped hose, and boots appears, running with her pink hoop toward the vision of flying hands and an odd brick chimney spewing white vapors. While the child in her anachronistic costume is by now a familiar motif in Bellmer's repertory, and the sexual symbolism of the smokestack is obvious, what can be the meaning of hands with too many fingers and mysterious brown eyes that gaze out from their palms?

A passage in Bellmer's *Anatomie de l'image* mentioned above provides the answer.[32] Discussing again the situation of his seated little girl who represses awareness of her sexual parts and transfers it instead to her armpit, the artist asserted the normality of this phenomenon. He wished, however, to introduce extreme, clinical examples of such displacements, and to do this he drew on the dated accounts of the Italian criminologist and physician Cesare Lombroso (1835–1909). Citing the latter's "Transferences of Sensation in Hysteria or Hypnosis,"[33] Bellmer offered cases of adolescent girls whose body images and behavior were severely disturbed by the onset of puberty: one girl's hysterical symptoms included convulsions, hyperaesthesia, and sleepwalking; she became blind but gained the capacity to see through her nose and left ear. "These phenomena," Bellmer continued, "are not isolated":

Another girl of fourteen, who also had just begun to menstruate, exhibited convulsive coughs, headache, fainting, spasms, facial convulsions accompanied by singing, sleep lasting sometimes three days, and attacks of somnambulism during which she saw distinctly with her hand and read in the dark.

As in the case of the little seated girl, there is an initial conflict between desire and its interdic-

tion, but this time as violent as the crisis of puberty that gave rise to it. Insoluble, this conflict can only lead to the repression of sex, to its projection onto the eye, ear, nose: a projection or displacement that explains to us . . . the hyperbolic valorization of the sense organs, the dramatization of their functions.

Child and Seeing Hands seems quite directly related to these case studies of female hysteria. Like Breton and Louis Aragon, who had celebrated "The Fiftieth Anniversary of Hysteria" in the pages of *La Révolution surréaliste* in 1928, Bellmer was fascinated by concepts of psychic disorder.[34] From the point of view of Surrealism, hysterical symptoms constituted the body's form of automatic writing, an involuntary protest against societal restrictions placed on sexuality. Entrenched for centuries in gender stereotypes—as rational males attempted to fathom the "mysteries" of an unruly female sex—hysteria[35] also fueled Bellmer's long-standing interest in another puzzle: the relation of mind and body.

He drew, as we have seen, from Schilder's studies of brain and body image, but he also followed Freud on the sexual etiology of the neuroses and incorporated the vocabulary of psychoanalysis in his work. In *Child and Seeing Hands*, the artist literalized the notion of psychic "defense" with a wall of bricks, and even speculated in *Anatomie de l'image* about the kind of trauma that might have caused Lombroso's girl to develop the specific symptoms referenced in his drawing:

To understand the motif of the second, manifest transference [Bellmer wrote], that of the eye onto the hand for example, one would have to believe that the eye, doubled by the condemned image of the sex, could not entirely conceal the compromising portion of its supplementary content. Let us suppose, without risk of serious error, that

some acts of an intimate nature had been seen, heard, perceived—in such a way that, under the influence of shock, repugnance, and a sense of guilt, the transfer or at first simply the loss of vision signifies: "I do not want to see anything, I do not want to see any more."

For Lichtenstein, Bellmer's "account of the materialization of hysterical conversion symptoms" also relates "to the distortions to which he subjected the body of the doll."[36] Indeed, many photographs of the second doll, especially those depicting its four-legged incarnation convulsed on a bare floor or bed (fig. 8) or arched over in a kind of back bend,[37] recall the thrashing bodies of hysterics documented by the famous nineteenth-century neurologist Jean Martin Charcot at the hospital of the Salpêtrière in Paris. Charcot's records, graphic and photographic, helped him to observe and systematize the different stages of hysterical attacks; among the characteristic postures he identified was the *arc en cercle*, or rainbow pose, with the back arching and both head and feet firmly planted on the ground or (more often) the bed.[38] In a turn-of-the-century romance about the Salpêtrière, one of Charcot's students, Jules Claretie, described a patient enduring one of these seizures—adopting an analogy that uncannily predicts Bellmer's doll: "The human being," wrote Claretie, "seemed reduced to the state of a machine, to one of those 'maquettes' of wood that sculptors use, bending the joints of these mannequins all around as they please—macabre caricatures of man."[39]

Sadly and ironically, such attacks were witnessed as well, decades later, by someone whom Bellmer knew intimately, the German Surrealist writer Unica Zürn. In 1954, a year after Bellmer met her on a visit to Berlin, Zürn moved to Paris with him, and the artist captured her in a typically somber, pensive mood

in a portrait now in the Art Institute's collection. On the verso of the sheet (fig. 13), a large, double-sided white-ink drawing on black paper, Zürn is shown standing, head lowered, eyes downcast, hands folded demurely in front of her, and dressed in a modest suit. A network of lines and bricks animates the background, while to the right, closer to the picture plane but also implicated in the abstract web, Zürn's face emerges in three-quarter view. Inexpressive and wide-eyed, she wears her hair tied back with a bow. Although photographs from the 1950s indicate Bellmer's relative faithfulness to Zürn's appearance in this likeness, his obsessive fantasy subsumes her image on the drawing's recto, the side he chose to sign and date (fig. 14). Here Bellmer transformed her into a *femme-enfant*, awkwardly displayed in a fanciful, transparent, pleated dress reminiscent of the one worn by the girl in *Child and Seeing Hands*; he also depicted her on all fours in striped stockings and Mary Janes. In the latter pose, the figure plays with a cat's-eye marble—a motif Bellmer introduced twenty years earlier in "Memories of the Doll Theme." Her pink hair-bow is real, the draw-

ing's single collage element and a staple feature in Bellmer's iconography of little girls.

Zürn left Bellmer temporarily in 1960 and returned to Germany. There she was admitted for the first time to a mental institution, diagnosed as schizophrenic. In the decade remaining to her, she was hospitalized intermittently in France, where she continued to live with Bellmer and to produce autobiographical texts, including the important *Der Mann im Jasmin: Eindrücke aus einer Geisteskrankheit* (*The Man in the Jasmine: Impressions from a Mental Illness*) and *Dunkler Frühling* (*Dark Spring*). In her writings, Zürn presented a poignant picture of illness from within the institution, from the point of view of the patient, which stands in contrast to the constructions of female madness in the diverse work of Charcot, Claretie, Breton, Aragon, and Bellmer.[40] At moments, however, she thought of Bellmer's monstrous inventions in terms of what she saw around her, detecting in the body of a fellow patient "a connection with his celebrated 'Cephalopod,' the woman with head and legs and without arms."[41] Speaking of herself in the third person, Zürn related:

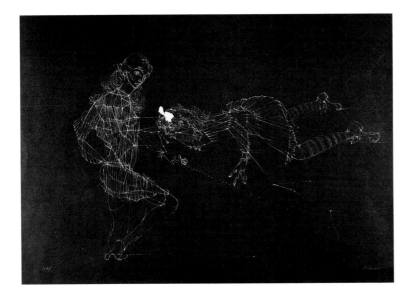

FIGURE 14

Hans Bellmer.
*Untitled (Double-Sided
Portrait of Unica
Zürn)* (recto), 1954. Pen
and white ink, and
pink ribbon on black
wove paper; 50 x 70 cm.
The Art Institute
of Chicago, Gift of
George A. Poole.

She saw this monster at [the hospital of] St. Anne: a mentally ill woman, in an erotic seizure, surrendering herself to her imaginary partner. . . . As if Bellmer were a prophet, the sick woman was horrible to see. All was in upheaval: her legs and back in the shape of an arc, and the terrible tongue; scenes of madness, of torture, and ecstasy: [these] are depicted by him with the sensitivity of a musician, the precision of an engineer, the rawness of a surgeon.[42]

During the course of their difficult relationship, Bellmer and Zürn collaborated in a number of ways, he providing postscripts and frontispieces for her publications, she posing for drawings and at least one painting.[43] In 1958 he made a group of shocking black-and-white photographs of her naked torso bound tightly with string, transforming her body into a series of folds and bulging mounds of flesh. One of these was reproduced on the cover of *Le Surréalisme, même* that year: showing Zürn reclining on a bed, seen from behind without head, arms, or legs—leaving only a pale lump of trussed meat—the image bears the necrophilic caption "keep in a cool place."[44] Like all of Bellmer's work, these photographs manipulate and distort the female body for the purposes of a complexly motivated male imaginary. Zürn was not the only model ever to place herself in the service of this compulsive project, but her tragic psychological vulnerability, which culminated in suicide in 1970, renders it especially disturbing. Reflecting on Bellmer's creative endeavors, she pointed to his extraordinary technical facility, "infinite gentleness," and circumspection, and yet admitted that the person "who is sketched by him, or photographed . . . by his pencil [*sic*] participates with Bellmer in the abomination of herself. Impossible for me," she concluded chillingly, "to render him greater praise."[45]

Leonora Carrington's Mexican Vision

CLARE KUNNY

Senior Lecturer
Department of Museum Education
The Art Institute of Chicago

Leonora Carrington's imaginative and fantastic painting *Juan Soriano de Lacandón* (fig. 1), now in The Art Institute of Chicago, was painted nearly twenty years after the English artist arrived in Mexico, the country in which she attained artistic maturity and has since made her home. The painting is a fascinating blend of Carrington's early European Surrealist roots and the magical naturalism native to Mexico. Although small in size, the jewel-like *Juan Soriano de Lacandón* magnifies Carrington's long-standing affinity with her adopted homeland.

Carrington was born in northern England to an upper-class family; her father was a wealthy textile industrialist. Although the Carrington children, Leonora and her two brothers, were raised conventionally, Leonora was independent and rebellious by nature; she set herself apart from family expectations. After several dismissals from convent schools in England, followed by failed enrollments at boarding schools in Florence and Paris, Carrington set her aim on becoming a painter. After finally convincing her parents of her unswerving ambition, she enrolled in the newly opened London Academy of the painter Amédée Ozenfant (1886–1966).

In London, Carrington was introduced not only to the disciplined drawing and other training necessary for her future endeavors as an artist, but to the individuals and exhibitions that were in the forefront of the current avant-garde. Two London events were to prove seminal for the artist: the International Surrealism Exhibition at the New Burlington Galleries in 1936, and a one-person exhibition of the Surrealist artist Max Ernst at the Mayor Gallery in 1937. The former exhibition, organized by artist and philosopher André Breton, included sixty artists from fourteen nations. Similar international Surrealism exhibitions took place in Paris in 1938, and in Mexico City in 1940. Such international group shows served to take Breton's theoretical notions "on the road," beyond the frontiers of France.[1] Carrington visited the London exhibition, and judging from her own painting at this time, must have found the work inspiring. *The Inn of the Dawn Horse* (fig. 2), a self-portrait from around 1936–37, illustrates her early interest in and knowledge of Surrealism. Within a sparsely furnished room reminiscent of the interiors of René Magritte, the young artist is seated — though hardly at rest — on a chair placed disjunctively against a wall. Her mane of dark brown hair flows as freely as that of the white

LEFT

Leonora Carrington.
Juan Soriano de Lacandón (detail).
See fig. 1.

Even though Leonora Carrington and Remedios Varo had been acquainted with each other in Europe, it was in Mexico that their shared sensibility came to the fore.

Here they found themselves at a distance from the pressures of the male-dominated Surrealist group.

FIGURE 1

Leonora Carrington (British, born 1917). *Juan Soriano de Lacandón*, 1964. Pencil and casein on board; 40.4 x 80 cm. The Art Institute of Chicago, Lindy and Edwin Bergman Collection (108.1991).

horse running outside the window. The window itself, like a proscenium, is elegantly draped as though it were dressing a stage set for the acting out of one's dreams. Inside, the sense of restless, untamed energy is heightened by the artist's peculiar companions. The contrast between the fixed artificial horse and the free, natural animal is apparent. Uneasy lighting provides an appropriately disquieting background to the strange and menacing presence of the hyena lurking close to the delicately extended hand of the artist. The hyena acts as both guard and guide to the young woman seated in a nurserylike setting. Crowned by the rocking horse, the woman's animal companions symbolize release, or a rite of passage. While horses played a prominent role in the young Carrington's life, both in tales told by her mother and nanny and in her own riding, her image of the hyena was certainly the product of the artist's invention rather than experience. This mixture of animal fact and fantasy, of nature and symbol, proved

to be a signature characteristic of Carrington's later work.

Carrington became part of the circle of Surrealists in London, initially through exposure to their art and ideas, eventually through introductions to Max Ernst and his friends.[2] Ernst became her mentor and her lover for three intensely creative years (1937–40), during which they lived together in France. Ernst's friends Nusch and Paul Eluard, Man Ray, Lee Miller, and Roland Penrose all recognized Carrington's ability to imagine her own tales and encouraged her to translate them into word and image. While she developed as a painter, her skills as a writer of fantastic tales developed in parallel sequence.[3] Carrington and Ernst shared an interest in folktales and myth, magic, sorcery, and the occult; they explored the connection between art-making and the artist's identity as a magician or shaman.[4] Both artists believed in selecting a totemic animal and alter ego: Ernst picked the bird he called Loplop, Carrington chose

the horse, which in various guises—mythical, hybrid, and ordinary—figures in her early paintings and stories.

The onset of World War II ended Ernst's and Carrington's creative idyll in southern France: Ernst was interned as a German. As a young foreigner living with an older German artist, Carrington was also considered an enemy alien; she fled France as the war commenced. Making her way through Spain, she arrived in Santander in a state of fatigue and distress. Diagnosed as unstable, she was interned in an insane asylum. Her family sent her nanny to ensure Carrington's release, but also to carry out a plan to send her to an asylum in South Africa. Carrington escaped from her nanny in Lisbon, and took shelter in the Mexican embassy, thanks to the assistance of her friend Renato Leduc, a Mexican diplomat who provided Carrington with a passport. Her marriage of convenience to Leduc in 1941 ensured Carrington's safe passage out of a Europe in turmoil and away from the clutches of her

family. Carrington and Leduc left Lisbon to spend a year in New York, where Carrington continued to paint and write, contributing to Surrealist journals and showing her work in group exhibitions. In 1942, the two settled in Mexico.

A number of artists who left Europe at this time congregated in two North American cities, New York and Mexico City, both of which were seen as new, vital contemporary art centers. The attraction of Mexico City was also due to two other factors. One was the innovative government-sponsored mural movement, which brought international recognition to Mexico. The second was the widespread view of the land and the people as magical, which had attracted artists, and many others, for over a century. A long list of European and American artists traveled and worked in Mexico before the European emigrés of World War II arrived.[5]

In Mexico, Surrealism had found a kindred spirit even before the arrival of Carrington and

FIGURE 2
Leonora Carrington. *The Inn of the Dawn Horse*, c. 1936–37. Oil on canvas; 65 x 81 cm. Private collection. Photographed by Barry Pribula, New York. (Detail)

her circle. Breton, the cofounder of Surrealism, was fascinated with Mexico, where he traveled in 1938 as a cultural ambassador. He pronounced his host country the "Surrealist place par excellence."[6] Indeed, French interest in Mexico was of long standing. Politically, the connection had been established with the ill-fated reign (1864–67) of the French Emperor of Mexico, Maximillian. Travel reports from Europeans returning from Mexico supplied eager imaginations with extraordinary ideas and myths. By the twentieth century, Mexican artists studying in Europe were taking with them visual versions of their native culture. Artistically, the fantasy paintings of the French artist Henri Rousseau formed an enduring bridge between the two countries. Rousseau gave credit to the exotic flora and fauna of Mexican jungles as inspiration for his potent proto-Surrealist imagery. (Having never visited Mexico, Rousseau found his inspiration for such imagery during his visits to the Jardin d'Acclimation [Botanical Garden] in Paris.)

In addition to Breton's visit five years in advance of Carrington's arrival, the seeds of

Surrealism were sown in Mexico through the influence of the "International Surrealist Exhibition," on view in 1940 at the Galería de Arte Mexicano in Mexico City. The exhibition served to encourage Mexican artists, steeped in the populist mural tradition, to recognize the value of easel painting based on individualism and introspection. This was further encouraged by the presence of European Surrealists and the work they were doing.[7] In the 1950s, Mexican artists such as Frida Kahlo, Manuel Alvarez Bravo, Maria Izquierdo, and Rufino Tamayo were producing small-scale, highly idiosyncratic work—an alternative art form to the native didactic mural tradition.

An educated class of European emigrés seeking asylum abroad was officially welcomed by the Mexican government under the leadership of Lázaro Cárdenas. Carrington became part of a closely knit European artistic community centered in the Mexico City neighborhood of Colonia San Rafael. She and Leduc agreed to an amicable divorce. Carrington remarried in 1946. She and the Hungarian photojournalist Emerico "Chiqui" Weisz celebrated their wedding (see fig. 3) with the close friends who represented the internationalism of Mexico City's art community. Among the celebrants were the Hungarian photographer Kati Horna, who took the group photograph, accompanied by Spanish emigrés Remedios Varo, Gerardo Lizárraga, and José Horna, the French Surrealist Benjamín Péret, the British-born Carrington, and Gunther Gerzso, who was born in Mexico of Hungarian parents, but was educated in Europe. These artists had in common their affiliation with Surrealism as well as their European background. For Carrington, close working relationships, friends, and motherhood marked these early Mexican years. Mexico initially offered peace and safety; eventually it also yielded creative inspiration and patronage.

FIGURE 3
Photograph of the celebration at the wedding of Emerico "Chiqui" Weisz and Leonora Carrington, 1946. Left to right: Gerardo Lizárraga, Weisz, José Horna, Carrington, Remedios Varo, Gunther Gerzso, Benjamín Péret, and Miriam Wolf.
Photo by Kati Horna (Hungarian, born 1912).

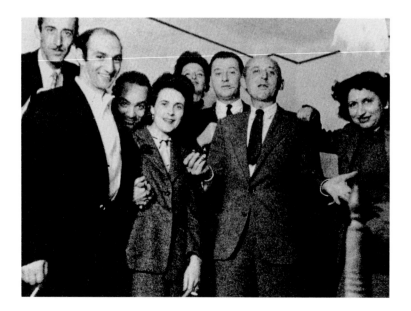

FIGURE 4

Gunther Gerzso
(Mexican, born 1915).
*Los Días de la Calle
de Gabino Barreda*
(*The Days of Gabino
Barreda Street*), 1944.
Oil on canvas;
41 x 55.5 cm. Private
collection. Depicted in
the group portrait
are, from left to right:
Carrington as female
torso; Gerzso with his
head in a box; Esteban
Francis, who plays
a guitar; Varo as a cat-
woman; and Péret
as a seated, dismem-
bered body.

As outsiders, the European expatriates were allowed to live life as they pleased, at a remove both from the conventions of the host culture and the culture they had left behind. They socialized mainly with one another, re-creating certain aspects of a European lifestyle in the Mexican setting, gathering at one apartment or another for fabulous dinners, lively conversations, and outlandish costume parties. Gunther Gerzso's group portrait *Los Días de la Calle de Gabino Barreda* (*The Days of Gabino Barreda Street*) (fig. 4) commemorates such gatherings. Calle de Gabino Barreda is the location of the apartment shared by the artist Remedios Varo, represented as the cat woman in Gerzso's painting, and her companion, Benjamín Péret, shown as a dismembered body above her. The landscape is filled with complex activities and symbols: smoke recalls the war in Europe; there are obscure references to five individuals, includ-

ing Carrington as the luminous, shrouded nude growing from a wretched, hunched body at the left.[8] The two women artists, Varo and Carrington, play the most prominent roles in this painting, and indeed they formed a deep and fruitful friendship. For both, their art took root and flourished in their adopted land. In this portrait, the voluptuous nude rising from the seated figure appears almost as a premonition, a metaphor for the flowering of Carrington's art in a Mexican setting.

Even though Carrington and Varo had been acquainted with each other in Europe—both participated in Paris-based Surrealist activities—it was in Mexico that their shared sensibility came to the fore. Here they found themselves at a distance from the pressures of the highly structured and ultimately male-dominated Surrealist group. The time they spent together affirmed their feminine autonomy as "daughters" of Surrealism and resulted

OPPOSITE PAGE FIGURE 6

Leonora Carrington. *The Temptation of Saint Anthony*, 1947. Oil on canvas; 120 x 90 cm. Private collection.

in an explosion of creativity. Meeting daily over a period of years, Carrington and Varo nourished each other spiritually and artistically. Collaborative, pseudoscientific experiments and the exchange of dreams and ideas took place in the kitchen as well as in the studio. Carrington's studio, where the two frequently met, was described by a friend as a "narrow little room in old Mexico, the most dream-saturated place I know here."[9]

FIGURE 5

Remedios Varo (Spanish, 1908–1963). *La Creación de las Aves* (*The Creation of the Birds*), 1957. Oil on Masonite; 54 x 64 cm. Private collection, Mexico City.

Carrington and Varo each had intense imaginative powers, and strongly believed in the spiritual and in the potential of magic. They used magic to explore woman's creative powers and the feminine affinity with nature. The natural universe is exquisitely displayed in Varo's painting *La Creación de las Aves* (*The Creation of the Birds*) (fig. 5). In her imaginary universe, a delicate, feminized participant serves as intermediary, or possibly as magician/scientist. Varo's art offers a vision of a world where the woman's role is creative and vital to its working.

As for Carrington, in the late 1940s her art moved away from totems and personal themes toward imagery with broader intentions. Her study of world religions (medieval Christianity, Gnosticism, the Kabbalah, Tibetan Buddhism) and eventually Jungian psychology further expanded her sources for imagery. Carrington's repertoire of animal images also increased. The creatures inhabiting the landscape in *The Temptation of Saint Anthony* (fig. 6), for example, are derived primarily from late medieval Christian symbolism. The saint's struggle to withstand temptation is underscored by the plump pig—a symbol of lust—snoozing in the foreground. Here, using her refined draftsmanship and an attention to detail reminiscent of that of the Netherlandish late medieval painter Hieronymous Bosch, Carrington imparted a new twist to this iconographic classic: the fact that Saint Anthony grasps a spindly tree hints at a flaw in his resolve, while the voluminous, tentlike robe intended to shield the saint seems as fragile as an eggshell, in contrast with the durable rock of the distant mountains.[10]

Carrington and the other European artist expatriates were able to develop their art relatively independently of their host country's culture. This insularity was, however, not only a self-imposed condition. Even though the emigrés were officially welcomed by the Mexican government, prominent Mexican artists were leery of the newcomers: the politicized Mexican avant-garde viewed them as foreign "colonizers." In 1943 the great Mexican artist Diego Rivera spoke out against the "'false artists' whom he accused of perpetuating the semicolonial condition of Mexican culture by imitating European modes."[11] Although nearly thirty years had passed since the Mexican Rev-

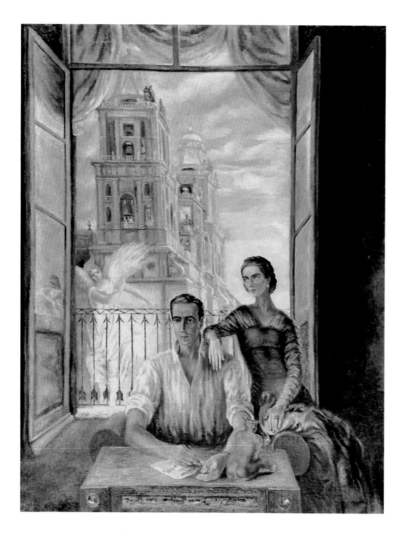

FIGURE 7

Juan Soriano
(Mexican, born 1920).
*Portrait of Ignacio
and Sofía Bernal*, 1948.
Oil on canvas;
97 x 76 cm. Collec-
tion of Mr. and Mrs.
Ignacio Bernal.

nish a link between Surrealist emigrés such as Carrington and Varo and the Mexican art community, when both artists received public commissions.[13]

Additional ties were bringing the two communities closer together: a new generation of Mexican painters was emerging. Juan Soriano, the subject of Carrington's exquisitely rendered painting in The Art Institute of Chicago (fig. 1), for example, came of age at the time of the European "invasion." Well aware of the European artists in Mexico City and familiar with Surrealist art, Soriano was especially fascinated with the lifestyle of the expatriate group.[14] Shortly after Carrington's arrival, she met Soriano at the home of Lupe Marín, a Mexican socialite who also had the distinction of being Diego Rivera's second wife. Soriano has been described as "essentially a lyrical and imaginative artist."[15] The degree to which the artist combined fiction and daily life in his fantastic genre scenes and portraits can be seen in his depiction of the aspiring anthropologist Ignacio Bernal and his wife, Sofía (fig. 7). The scientist, who was to be instrumental in the modernization of the Museo Nacional de Antropología e Historia de México in Mexico City, sits at his desk studying an ancient figurine. His wife rests on the arm of his chair. Behind them an open window offers a view of an immense colonial church. Using the same window, the artist introduced into this relatively conventional scene an alternate and supernatural reality in the form of an angel fluttering just outside the balcony.

Carrington and Soriano found they shared an interest in stage sets and theater. Along with the writer Octavio Paz and other artists, they joined forces in 1956 to form the theatrical group "Poesía en Voz Alta" ("Poetry Read Out Loud"). Theater offered an opportunity for collaborative projects.[16] Carrington,

olution, the nation's art in the 1940s was dominated by revolutionary socialist ideology. As mentioned above, mural painting was the national art form: monumental in scale, didactic in sentiment, and public in intent. Its mission was in part to teach all Mexicans about the importance of their indigenous past, and the socialist value of land reform and literacy. In contrast, Surrealism was an art based on introspection, in which probing the unconscious and the higher intellect was critical. This philosophical schism served to further distance the two groups of artists.[12] Ironically, by mid-century, mural painting would fur-

Soriano, and Varo all contributed to productions in a variety of ways: designing sets, creating costumes, and acting. Carrington also contributed as a writer, adapting literature and some of her own stories to the stage.[17]

Role-playing and make-believe, laced with humor, was part of all three artists' creative lives. References to these activities and their rich friendship frequently appear in their work, most notably in two portraits, one by Varo and one by Carrington. In Varo's *Portrait of Baron Angelo Milfastos as a Child* (fig. 8), Soriano is transformed into Baron Angelo Milfastos, a villainous little boy seen afloat at sea. Dressed in the knickers and skimmer of a child, he stares balefully out at the viewer. In the boat at his feet lies a severed head; a knife behind the child implicates him in the deed.

This sinister portrait of her friend was designed by Varo as Soriano's birthday card.[18]

Leonora Carrington cast Soriano in an equally challenging role—that of a Lacandón Indian—in *Juan Soriano de Lacandón*. By presenting the artist as a shaman, she seems to have been acknowledging his interest in the extraordinary while indicating his awareness of Mexico's ancient past. Telltale signs indicate the figure's supernatural powers: the "Maya-blue" eyes lock in a trancelike stare, tattoos mark the face.[19] Also unusual is the carved, columnar neck—closer to sculpture than to human anatomy. Indeed, Carrington may have patterned Soriano's likeness after ancient Maya clay figurines whose distinct ethnic features bear markings and scarification patterns (see fig. 9). Carrington cleverly found a corre-

FIGURE 8

Remedios Varo. *Portrait of Baron Angelo Milfastos as a Child*, c. 1952. Pencil on paper; 12.2 x 15 cm. Collection of Ruth Davidoff, Mexico City.

spondence between Soriano's prominent, long nose and the Maya preference for a "Roman" nose that forms a continuous slope from hair-line to tip. The "Roman" nose identified an individual as a person of high social status in Maya society. Soriano's own natural blue eyes present an additional fortuitous correspondence with Maya traditions of art, and mark him as unusual (see fig. 10).

Carrington's association of Soriano with ancient Maya extended to their descendants, the contemporary Lacandón. Soriano's hair and clothing, as well as the hammock on which he reclines, are characteristic of the Lacandón, who live in the southern state of Chiapas in Mexico.[20] Although Soriano is much larger and clearly commands the scene, his identical dress and hair link him to similarly articulated figures scurrying around at the bottom and left side of the image. All of the figures, including that of Soriano, in the role of a shaman, are shown in harmony with the natural order: the lush setting is replete with palms and water lilies; the ceiba tree anchoring the right edge denotes a sacred place.[21] The landscape is also thickly populated with animals: howler monkeys leap over a large jaguar; an owl, a deer, and a hummingbird (a protecting ancestor) appear above the shaman along with numerous other creatures. The flora and fauna are native to Chiapas, a humid, densely vegetated highland region. Although the creatures and setting of *Juan Soriano de Lacandón* refer to reality, their ritualized presentation in the painting is impregnated with the sense of magic. In the Maya worldview, privileged individuals such as shamans can gain access to uncommon forces. The shaman's extraordinary powers as intermediary are demonstrated in the four serpents that emerge from a watery surface and lean forward as though in conference. Serpents and water are traditionally associated with the

Mayan underworld, while other animals located near the shaman in the painting serve as attributes identifying him with earthly and cosmic realms.

This portrait demonstrates how Carrington used her careful observation of external reality to generate a vision of the otherworld. She accomplished this in part by metamorphosing an inanimate creature into its animate counterpart. Here the jaguar greatly admired by the Lacandón and their ancient ancestors,[22] as a spiritually powerful creature connected to cosmic forces, assumes a primary role, both compositionally and narratively. The composition is divided vertically into two halves: the left side is dominated by a statuesque, elegantly posed feline; Soriano practically levitates among the animals and heavy vegetation on the right. His hand holds, as a connective device, a small replica of the spotted cat that mirrors the larger creature at the

left. The large jaguar is bathed in peach-colored light, as though it is a vision from a remote realm. The replica also radiates an aura, as if the moment of transformation has been recorded, the magic stored.

In this portrait, Carrington employed imagery and allusion to weave Juan Soriano into his country's history. This is unusual for her art up to that point: the work she did for the nearly twenty years since her arrival in Mexico shows scarcely any obvious Mexican influence.[23] That this fanciful portrait of Soriano is clearly connected to past and present Mexico is a testimony to her feelings for the artist, which continue to this day. Their friendship demonstrates the eventual dissolution of barriers between the European and Mexican artist communities and is evidence of Carrington's own gradual, yet thorough, immersion in Mexico. During the 1940s,

Carrington acclimated herself to Mexico; in the 1950s, she came of age as a Mexican artist, participating in a number of exhibitions and group projects.[24] This transition reached its culmination in 1963, when the Mexican government commissioned Carrington to create a mural for the Museo Nacional de Antropología e Historia de México in Mexico City (see figs. 11–12).

This modern home for Mexico's extraordinary collection of ancient art symbolizes the country's expansionist sentiment regarding cultural identity and achievements. In the 1950s and 1960s, the museum's director, Ignacio Bernal, along with other scientists, scholars, and artists, was engaged in identifying a new, specifically Mexican, realm of civilization to explore.[25] Reclamation of the ancient past, through archaeological work and ethnographic studies, was a means toward a national iden-

FIGURE 10
Juan Soriano.
Self-Portrait, 1952.
Oil on canvas;
80 x 60 cm. Collection
of Marek Keller,
Mexico City.

tity that acknowledged the pre-Hispanic as well as the Spanish colonial past. The many significant layers of Mexico's heritage can be seen in Juan Soriano's double portrait of Ignacio and Sofía Bernal: while colonial Catholicism looms large in the background church, Bernal, as we have seen, examines a small fragment of pre-Hispanic Mexico, which apparently has just been unearthed (fig. 7). Tangible evidence of pre-Hispanic civilizations, in the form of ceramic and stone sculpture and ancient ceremonial sites, as well as colonial documentation by the Spanish of their new subjects, stimulated modern Mexican arts, ranging from public mural projects and performances to small-scale private endeavors of poets and painters.

Carrington's 1963 government commission allowed her to participate fully in this renaissance as a Mexican artist. The project required that she work directly with Mexican

subject matter, specifically with a monumental composition that would serve to enhance the museum's installation of ancient Maya art. The title of her mural, *El Mundo Mágico de los Mayas* (*The Magical World of the Maya*) (see fig. 11), suggests the potency she found in her subject. Carrington began by assuming the role of an anthropologist; she spent months gathering information first-hand on site in Chiapas, observing the Lacandón Indians at their daily routines. Carrington's host in San Cristobal de las Casas, the Swiss anthropologist Gertrude Blom, knew of the artist's interest in magic and the occult, and introduced her to the local healers, the "curanderos."[26] In deference to the Lacandón ban on cameras, Carrington filled sketchbooks with drawings and notes. In addition to her observations of the Indians, Carrington studied all the creatures native to southern Mexico at the state zoo in

FIGURE 11

Leonora Carrington. *El Mundo Mágico de los Mayas*, 1965–66. Casein on fibracel; 63.5 x 106.5 cm. Collection of Mr. and Mrs. Víctor and Masha Cohen. This painting is a version of the 1963 mural commissioned by the Mexican government.

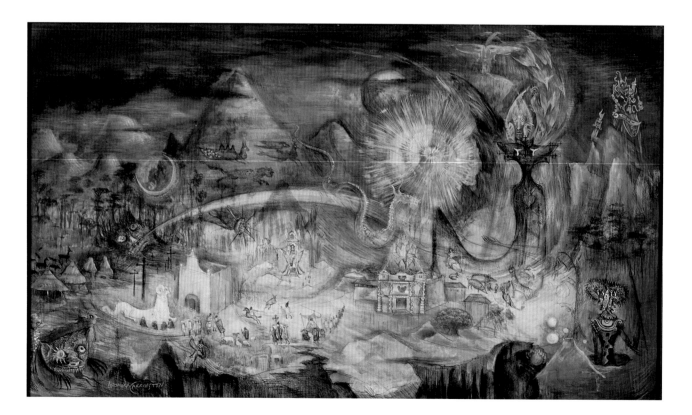

Tuxtla Gutierrez. Once she had informed herself in this way, she began to focus on understanding the otherworld of the Maya that operates behind the world of experience.

To discover the Maya vision, Carrington turned to literature, especially colonial manuscripts, which supply philosophical and sacred information gleaned from Maya informants by Spanish missionaries. Two texts served Carrington as primary sources for mythic material: *The Popol Vuh*, a sixteenth-century record of the ancient creation myth of the Quiche Maya of northern Guatemala; and the eighteenth-century council book of the Yucatec Maya, *Chilam Balam*.

El Mundo Mágico de los Mayas was placed in the Museo Nacional de Antropología e Historia de México in 1964, where it remained until the late 1980s, when it was moved to the Chiapas museum in Tuxtla Gutierrez. The project also resulted in a book published by the Museo Nacional that includes reproductions of numerous sketches. Several related paintings were made between 1964 and 1966, including *Juan Soriano de Lacandón* (fig. 1) and the small version of *El Mundo Mágico de los Mayas* (fig. 11). The mural offers an overview of the Maya world, where material fact—such as the colonial church, clusters of Lacandón in their white tunics, and the rugged landscape—has been permeated by magic. As in the close-up view presented in *Juan Soriano de Lacandón*, here again the animate and inanimate, human and animal, contribute to the harmony. In the Art Institute's painting, a metaphor for Carrington's affinity with her subject—and thus with her adopted homeland—may be found in the howler monkey, one of the creatures she portrayed frolicking in the jungle. In Yucatec Maya, the term for monkey also means artisan; in ancient Maya myth, the monkey served as an attribute for artists.[27] In artistic

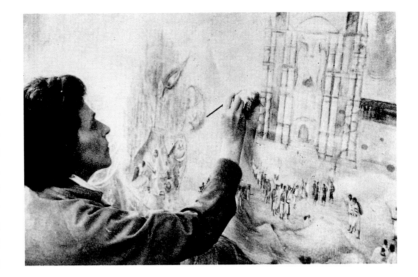

agility, Carrington was a match for the physical versatility of the monkey. She became increasingly adept at encompassing vast expanses of knowledge and imagination. While her early work reflects personal themes, her Mexican paintings developed from the multiplicity of her experiences, mingled with her embrace of intellectual knowledge spanning thought from Celtic myth to Maya beliefs.

At the age of seventy-nine, Leonora Carrington continues her creative journey with her writing, painting, and, recently, sculpting. The central position of Mexico in Carrington's life and artistic endeavors was confirmed by her return in 1991 to Mexico City, after living in the United States for the previous six years. Although *Juan Soriano de Lacandón* and the related mural *El Mundo Mágico de los Mayas* mark a central point in Carrington's mature career, they represent a unique interlude, not an endpoint. Carrington's worldview is all-encompassing. Her sphere of reference lies beyond temporal and national boundaries in areas that are vast and far-reaching, and seemingly never-ending.

FIGURE 12

Leonora Carrington painting the mural *El Mundo Mágico de los Mayas*, 1963.

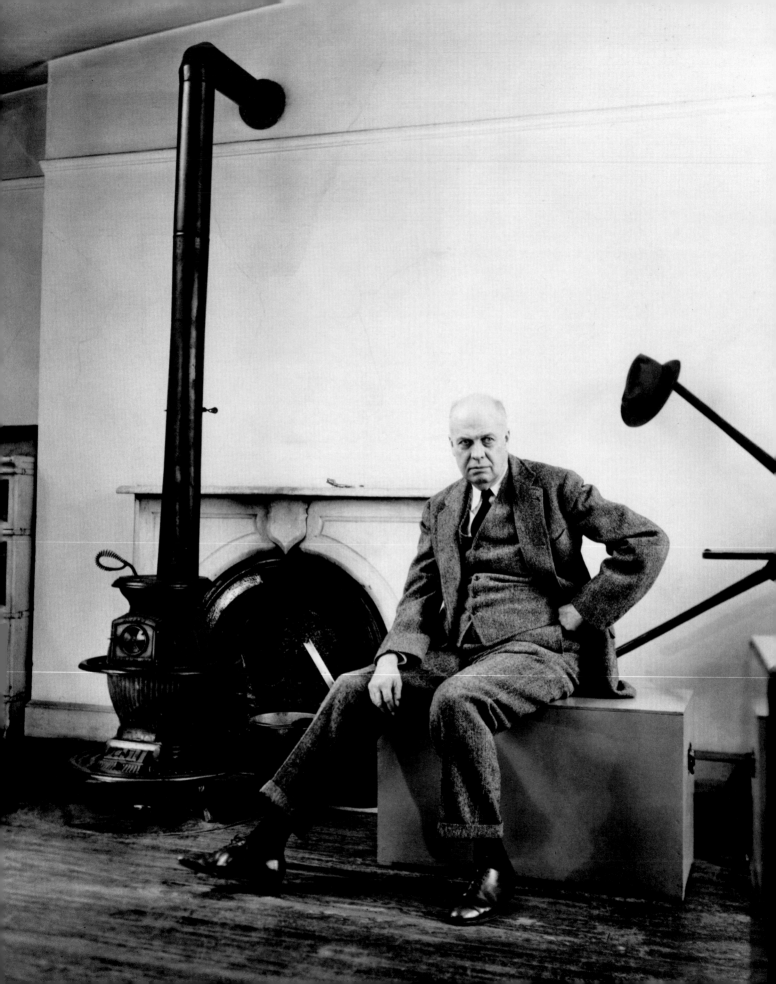

Edward Hopper's *Nighthawks,*
Surrealism, and the War

Professor of Art History
Baruch College and the Graduate School of
The City University of New York

We all know Edward Hopper as a great master in the ranks of American realists.[1] Few would readily link him to the European movement known as Surrealism. Yet the very galleries at the fledgling Museum of Modern Art, where Alfred H. Barr, Jr., the museum's founding director, hung Hopper's first retrospective in 1933, played host just three years later to the first major show of Surrealist art in New York ("Fantastic Art, Dada and Surrealism"). Such shows at the Modern had been regularly attended by Edward and Jo Hopper ever since the museum's founding in 1929, as Jo recounted in the diaries that she kept from the early 1930s on. The Surrealists' opening was no exception. What Edward liked, he told Jo, was their fine use of color; some of them, he observed slyly, were better artists than they realized.[2] Knowing Hopper's own aesthetic predilection for realism, we can imagine him preferring the ironic verisimilitude of painters such as René Magritte and Salvador Dali. Magritte's claustrophobic spaces bear an affinity with Hopper's own.

Other affinities between the Surrealists' art and Hopper's work were not hard to see. In Barr's show, a number of artists featured dream imagery and nocturnal visions—from Dali's *The Persistence of Memory* (1931; The Museum of Modern Art, New York) to Yves Tanguy's *The Storm (Black Landscape)* (fig. 2). The latter emphasizes night, which had early fascinated Hopper, who produced etchings of uncanny scenes such as *Night on the El Train* in 1920 and *Night Shadows* and *Night in the Park* in 1921 (figs. 3–5). Although Hopper was more circumspect than the Surrealists, something of their concern with sexuality and psychological introspection underlies the aesthetic that he articulated for the catalogue of his 1933 retrospective: "I believe that the great painters, with their intellect as master, have attempted to force this unwilling medium of paint and canvas into a record of their emotions. I find any digression from this large aim leads me to boredom."[3]

More revealing than his painfully spare prose is an introspective self-caricature that Hopper produced around the time of the Surrealism show representing an imaginary dream —*Le Rêve de Josie* (fig. 6). In the role of the man of "Jo's dream," Hopper sketched himself as a dude, decked out in tweeds and cape, a feather tucked into his hat band, peering through a monocle. Yet the hands are as hirsute as the suit, and the socks slip, revealing shanks as prickly as the hands. To one side sits a wicker basket crammed with heavy reading.

Hopper's use of French in addressing this drawing to Jo reflects their lifelong inter-

Our awareness of Hopper's expressed admiration for some of the Surrealists' work should help us to understand better the complexity of Hopper himself.

est in the culture from which the Surrealists emerged, starting with the movement's favorite poetry. The Hoppers' enthusiasm for French Symbolist poets began with Paul Verlaine, whom they quoted to each other while courting, and grew to encompass Stéphane Mallarmé and Arthur Rimbaud, who is sometimes referred to as a pre-Surrealist and was admired by André Breton, among others.[4] Yet the word "dream" in the drawing's title also evokes the vogue of dream analysis and the impact of Sigmund Freud and Carl Gustav Jung. Hopper had long shared with the Surrealists an interest in Freud. Freud's ideas figure in the first Surrealist Manifesto, which Breton published in 1924: "Freud very rightly brought his critical faculties to bear upon the dream."[5] But as early as 1913, Freud was already a topic of discussion in Greenwich Village, when Hopper first moved to Washington Square, where he was to remain for the rest of his life.

Freud stimulated conversation and much activity in the avant-garde circle that buzzed around the salon of Mabel Dodge, which was a short walk up Fifth Avenue from Hopper's studio. Although Hopper never seems to have been part of Dodge's circle, Freudian notions provoked plenty of discussion in other quarters. Hopper certainly rubbed shoulders with Freud in the popular press when his illustrations for "The Hero Business," a story by Edith Mirrielees, appeared in the June 1915 issue of *Everybody's Magazine* along with Max Eastman's "Exploring the Soul and Healing the Body."[6] Eastman, a defining spirit of Village culture, discussed the "two schools of psycho-analysis" headed by Freud and Jung,[7] whose names figure prominently in another self-caricature by Hopper. He depicted himself as a skinny child with outsized embryonic head and huge eyeglasses who clutches under his arm two books labeled "Jung" and

"Freud." The drawing wittily combines the ideas of the impressionable infant, vulnerable to neuroses, and the adult "voracious reader" fascinated with the latest fashion for "dissecting the human species," which is how Hopper's satiric bent was once described.[8] Hopper was capable of talking about Freud for an entire evening, as Jo reported in one of her diary entries; and his comments in an interview years

later confirm his enduring interest in psycho-analytic ideas.[9]

Prominent among these ideas was the belief expressed by Jung that "dreams give information about the secrets of the inner life," which otherwise remains hidden from consciousness.[10] A desire to plumb such inner depths informs Hopper's statement, quoted above, that he sought to capture his emotions

through art. Likewise, the idea of a contrast between outer and inner reality informs the caricature *Le Rêve de Josie*, with its representation of the contrast between artificial smartness on the outside and natural awkwardness beneath.

Surrealism, the War, and *Nighthawks*

In the later 1930s, as tensions rose in Europe,

FIGURE 1

Edward Hopper (American, 1882–1967). *Nighthawks*, 1942. Oil on canvas; 84.1 x 152.4 cm. The Art Institute of Chicago, Friends of American Art Collection (1942.51).

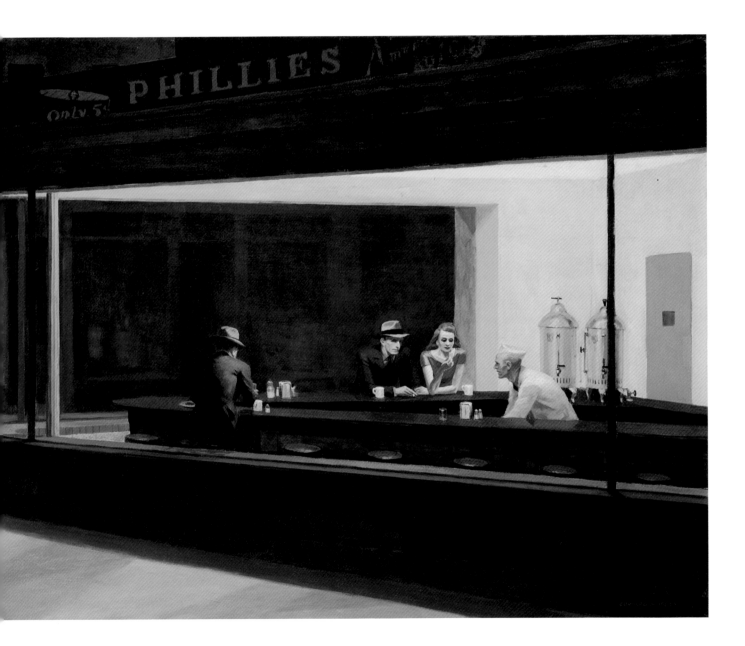

FIGURE 2

Yves Tanguy
(American [born
France], 1900–1955).
*The Storm (Black
Landscape)*, 1926.
Oil on canvas; 81.3 x
65.4 cm. Philadelphia
Museum of Art
(1950–134–187).

the Surrealists and other vanguard artists found themselves vilified and threatened. Many sought refuge in New York, where The Museum of Modern Art had prepared the way for their art. The Europeans attracted attention from critics, galleries, and collectors, often at the expense of Americans such as Hopper. In the long run, the wave of immigrants would revolutionize the American art scene. At the time, their plight received much attention in the press and communicated a growing sense of uneasiness about the war.

Matta, the young Chilean Surrealist, arrived in New York from France on November 1, 1939, and in March 1941 his painting *Invasion of the Night* (fig. 7) was featured in an exhibition on Surrealism arranged by the art

dealer Howard Putzel at the New School for Social Research in Greenwich Village, which was not far from Hopper's studio on Washington Square. (A number of the Surrealists, including Breton, Matta, Tanguy, and the painter Gordon Onslow Ford, were also living in Greenwich Village in the early forties.) Accompanying the exhibition was a lecture series, "Surrealist Painting: An Adventure into Human Consciousness," delivered by Onslow Ford.

Onslow Ford spoke of his close friend Matta's fascination with "psychic landscape" in terms that recall Hopper's interest in introspective moods and his own admission that in *Nighthawks* (fig. 1) he painted from his "unconscious." Onslow Ford concluded by praising the "bleak landscapes" of American Surrealist Kay Sage (the wife of the French Surrealist Yves Tanguy) for "creating an atmosphere where some important drama is bound to be enacted."[11] Exactly the same might be said of the atmosphere created by Hopper with the realist setting of *Nighthawks*.

Whether or not the Hoppers attended Onslow Ford's lectures or saw the accompanying Surrealist exhibition, Matta's theme of "night invasion" was about to become an urgent preoccupation in their lives. They would come to feel exposed to imminent invasion both in their Cape Cod retreat and in New York, under the skylights of their top-floor walk-up studio.[12] By the late summer of 1940, Edward wrote to his old friend Guy Pène du Bois: "We are evidently eye witnesses to one of those great shiftings of power that have occurred periodically in Europe, as long as there has been a Europe, and there is not much to be done about it, except to suffer the anxiety of those on the side lines, and to try not to be shifted ourselves."[13] He also gave a clue as to how he would deal with the anxiety: "Painting seems to be a good enough refuge from all

this, if one can get one's dispersed mind together long enough to concentrate on it."

As it turned out, Hopper did not find it possible to paint again until the following February: on Valentine's Day, he conceived the striking picture *Girlie Show* (1941; private collection). A further attack of painter's block led the Hoppers to travel West that summer in search of subjects. Back in New York in November 1941, Hopper again found himself stymied before a blank canvas in his studio —which is how he appears in a photograph by the young Arnold Newman, who caught the inwardness and tenseness of his subject, and even the difficulty of filling a canvas (fig. 8).

Notably, Hopper would have seen the exhibitions of Joan Miró and Dali that opened at The Museum of Modern Art in November 1941. Since the beginning of the previous year, the Hoppers had become members of the Modern; Jo wrote in her diary that she and Edward had been invited to everything since the museum's founding in 1929, and that "it's high time we joined."[14] Hopper would have found something to applaud in the essay by James Johnson Sweeney in the Miró exhibition catalogue, which quoted Miró on the importance of subject matter: "Have you ever heard of greater nonsense than the aims of the abstractionist group?"[15]

FIGURE 3

Edward Hopper. *Night on the El Train*, 1920. Etching, printed in greenish-black on white wove paper; 18.7 x 20.1 cm. The Art Institute of Chicago, Gift of the Print and Drawing Club (1944.154).

It was mid-November when Newman found Hopper unable to paint. A month later, Hopper had concentrated enough to begin the canvas that would eventually be called *Nighthawks* and become his most famous work. Jo considered that Edward's concentration on the painting was preternatural, in view of the alarm and agitation that gripped all New York and certainly herself in the wake of the Japanese bombing of Pearl Harbor on December 7:

Ed refused to take any interest in our very likely prospect of being bombed—and we live right under glass sky-lights and a roof that leaks whenever it rains. He refuses to make for any more precautions and only jeers at me for packing a knapsack with towels and keys and soap and check book, shirt, stockings, garters in case we ran to race out doors in our nighties. For the black-out we have no shade over the sky light . . . but Ed can't be bothered. He's doing a new canvas and simply can't be interrupted! The Rehn gallery invites E. to remove some of his pictures to a store house so that the whole collection won't be in one place. Frank Rehn is very concerned and making many precautionary measures. I can't say I'm a bit panicy [*sic*] but I'm the kind that believes in precautions, and in a matter that everyone is concerned in, I can't see why anyone refuses to take an interest. Hitler has said that he intends to destroy New York and Washington. . . . It takes over a month for E to finish a canvas and this one is only just begun. . . . E. doesn't want me even in the studio. I haven't gone thru even for things I want in the kitchen.[16]

Edward Hopper. *Night Shadows*, 1921. Etching and drypoint on white wove paper; 17.7 x 21.1 cm. The Art Institute of Chicago, Gift of the Print and Drawing Club (1944.156).

FIGURE 5

Edward Hopper. *Night in the Park*, 1921. Etching printed in black on white wove paper; 17.5 x 21.1 cm. The Art Institute of Chicago, Gift of the Print and Drawing Club (1944.158).

FIGURE 6

Edward Hopper. *Le Rêve de Josie*, 1936. Pencil on paper; 27.9 x 21.6 cm. The National Portrait Gallery, Washington, D.C.

Over a month then passed before January 22, 1942, when Jo reported in a letter to Edward's sister Marion in Nyack:

Ed has just finished a very fine picture—a lunch counter at night with 3 figures. Night Hawks would be a fine name for it. E. posed for the 2 men in a mirror and I for the girl. He was about a month and half working on it interested all the time, too busy to get excited over public outrages. So we stay out of fights.[17]

It seems clear that, in this extraordinary burst of concentration and creativity, Hopper was finding the refuge from war anxiety that he had envisioned in his letter to Du Bois the year before. He did so by assembling a number of motifs from his own earlier works and from his

reading—a process of assembling his "dispersed mind."

By pulling together with heightened intensity themes and forms that had permeated his mind and had long attracted critics and the public to his paintings, Hopper managed to create what is arguably his masterpiece. Heretofore *Nighthawks* has not been discussed in the context of World War II because it is such an early and personal response to the involvement of the United States in the war, which in any case it does not depict directly. Yet Hopper's cranky refusal to deal openly with the issues raised by the war and pressed upon him by Jo differs from the recalcitrance he so often showed when she tried to goad him out of depression into painting. In this case, he painted furiously with her loyal support; she modeled for him as needed or kept out of his way. His bullying concentration unconsciously reveals the depth of his fears about the war, which fueled a work of exceptionally disquieting power. Hopper's response to the imminent threat of war was not dissimi-

lar to that of the Surrealists.[18] Our awareness of Hopper's expressed admiration for some of their work should help us to understand better the complexity of Hopper himself.

The Initial Reception of *Nighthawks*

On St. Patrick's Day of 1942, the Hoppers went to The Museum of Modern Art to attend the opening of an exhibition of the art of Henri Rousseau. The exhibition was organized by Daniel Catton Rich, director of The Art Institute of Chicago, who had shown Hopper's work most recently the previous autumn at the Art Institute. When Alfred Barr "spoke enthusiastically of [Hopper's 1940 painting] 'Gas,'" which is in The Museum of Modern Art, Jo told him he just had to go to the Frank K. M. Rehn Gallery to see *Nighthawks*.[19] It was Rich, however, who went to the gallery; he pronounced *Nighthawks* "fine as a Homer," and arranged its purchase for the Art Institute. On May 11, Frank Rehn called Hopper to say that the Art

FIGURE 7

Matta (Roberto Sebastian Antonio Matta Echaurren) (Chilean, born 1911). *Invasion of the Night,* 1941. Oil on canvas; 96.5 x 152.7 cm. San Francisco Museum of Modern Art, Bequest of Jacqueline Marie Onslow Ford.

Institute had made the purchase, paying for *Nighthawks* in part by trading Hopper's smaller canvas *Compartment C, Car 293* (1938; now in the collection of the IBM Corporation), which the Art Institute had purchased after showing it in 1938 in its annual exhibition. Rehn told Edward that he had shown *Dawn in Pennsylvania* (1941; collection of Daniel J. Terra) to Barr, who said he thought Hopper was "the most exciting painter in America," causing Jo to reflect: "One is glad that Barr can find the excitement latent in E's silent, austere, outwardly serene pictures."[20]

The importance Rich attached to his new acquisition was underlined that autumn when the Art Institute awarded the Ada S. Garrett Prize—seven hundred and fifty dollars, given for "an oil painting by an American artist"—to Hopper for *Nighthawks*. Hopper's preoccupation with the war led him to take part that fall in the "Artists for Victory" exhibition at The Metropolitan Museum of Art in New York. But inevitably his attention turned to Chicago, where the Art Institute showed its new acquisition in "The Fifty-Third Annual Exhibition of American Paintings and Sculpture," which featured a memorial show of the work of Grant Wood, who had died earlier that year. The "biographical note" on Hopper in the exhibition catalogue states:

EDWARD HOPPER was born in Nyack, New York, in 1882. His early work aroused so little interest that he gave up painting for several years. In 1924 a one-man show of water colors which he had recently executed was received with such enthusiasm that he felt sufficiently encouraged to continue a career of painting. He began once more to work in oils and was soon acclaimed as one of the outstanding champions of honestly American subjects. He is noted for his clear-cut compositions, luminous color, and interest in light

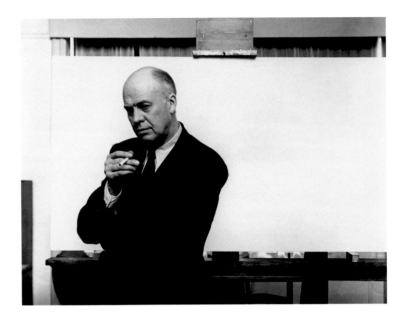

effects. His paintings are expertly designed, never overcrowded, and contain few people, though the buildings themselves are alive with personality.[21]

Hopper's active involvement with the Art Institute continued into the spring of 1943, when he traveled to Chicago to judge the "Twenty-Second International Exhibition of Water Colors" together with the Chicago painter Ivan Albright and Herman More, curator of the Whitney Museum of American Art in New York.[22] A photograph taken during their meetings at the Art Institute on April 13 and 14, 1943, documents the jury (fig. 9). The Art Institute's press release, written by Katharine Kuh, who later became the museum's first curator of twentieth-century art, identified Hopper as the "noted New York artist" and described him with even greater enthusiasm:

EDWARD HOPPER, famous exponent of the so-called "American Scene," is also an outstanding nationally known artist. His work, like that of Albright, has been shown in every recognized

FIGURE 8

Arnold Newman (American, born 1918). *Edward Hopper in His New York Studio,* 1941. Photograph. ©1980 Arnold Newman.

Jury for the 1943 "Twenty-Second International Exhibition of Water Colors" at the Art Institute. Left to right: Herman More, Curator of the Whitney Museum of American Art, and the artists Ivan Albright and Edward Hopper.

museum in the country and has been awarded many prizes. Hopper first became known as an etcher, but since 1924 his water colors and paintings have received constant public attention. He has a great genius for taking a simple American scene and imbuing it with poetic realism."[23]

Reviewing the show, the Chicago critic Eleanor Jewett complained: "There is little that is 'international' about this year's exhibit, altho the word is retained in the title. War has prevented participation on the part of those countries which a decade ago were among the most intriguing contributors."[24] In terms of the works exhibited, however, it is interesting to note that Hopper, Albright, and More chose some of the European artists living in exile in the United States, namely Marc Chagall, Fernand Léger, and the Surrealist André Masson. Also exhibited were some Americans, such as O. Louis Guglielmi and James Guy, whose work was clearly influenced by Surrealist art.

In his foreword to the exhibition catalogue, Frederick A. Sweet, the Art Institute's curator of painting and sculpture, discussed the impact of the war on American artists:

Chicago's Twenty-second International Exhibition of Water Colors opens after the country has been at war for nearly a year and a half. During this period large numbers of our artists have joined the armed forces and the numbers continue to increase as the weeks go by. For this reason many excellent artists are not represented in the exhibition and numerous others are showing for the last time until after the war. We are glad, however, to see a few men sending work from army camps in spite of the fact that they have so little time to paint. Service men's work is for the most part either straight reporting of camp activities or humorous anecdote. The horrors of war do not seem to concern them since they have not yet been overseas and are not in any case inclined to dwell on the gruesome side of their duties. Artists depicting the realities of warfare are usually those who are not in service but feel very strongly about the principles involved.[25]

As Sweet went on to explain, "Many civilian artists are fascinated by war plants, shipyards, and army camps, but strict regulations prevent their painting from direct observation anything having to do with war activities." He also noted the reduction in opportunities for travel that changed the working habits of Hopper, among others: "Gas rationing and restrictions on travel have curtailed artists' accustomed trips to the country, with the result that there is a greater emphasis on city scenes. Such rural landscapes as there are in many instances represent last summer's final country vacation and will presumably be seen in ever-decreasing numbers from now on."

Elsewhere in his foreword, Sweet remarked that "a lack of many war themes does not mean that the American artist is not thinking about the war or is not concerned with it"—an obser-

vation that precisely fits Hopper's case and the dynamic force embodied in *Nighthawks*. Sweet also noted the inclusion in the exhibition of "several emigree European artists" with the Americans "as they have in most cases expressed their desire to become American citizens" and he called attention to the American artist William Gropper's "biting satire . . . so masterfully directed toward anti-Nazi propaganda." As his essay clearly demonstrates, the war was on everyone's mind.

The Art Institute turned to Hopper again later in 1943 when the catalogue for the "Fifty-Fourth Annual Exhibition of American Paintings and Sculpture" proclaimed: "This year for the first time the Art Institute has included in the Annual American Exhibition a one-man showing of the work of a living American artist. Edward Hopper has been selected for this occasion and is represented by twenty-one paintings."[26] Sweet, who also organized this show, now wrote of Hopper:

A slow worker, he has always maintained complete independence from either academic trends or so-called fashionable modern tendencies. Strictly honest and direct he paints matter-of-fact subjects which to him typify the background of the average American's life. . . . To represent topically a single incident would be to reduce the composition to the trivial. Hopper gives us a larger conception, simplified to its essence.

Sweet went on from this general account of Hopper's style to praise *Nighthawks* as a powerful exemplar of "the intensity of his recent work, daring in design and dramatic in lighting." Sweet described the observer "amazed at so much dynamic force being contained within such calm and uneventful surroundings."

In contrast to Sweet's emphasis on Hopper's Americanism, which became the predominant point of view on the artist, the

critic for the *Chicago Daily News*, Clarence J. Bulliet, wrote: "Hopper has imagination, invention and a subtle feeling for what is alive, without exhibitionism. He has the psychological insight of the best of the 'Surrealists' without their circus methods."[27] Unerringly Bulliet sensed the affinity with Surrealism that we were describing above.

Hopper and His Affinities with Surrealism

The affinities between Hopper and Surrealism also struck some of the Surrealists and their earliest American enthusiasts. The avant-garde journal *View* (founded in 1940 by Charles Henri Ford) involved some of the Surrealists in New York and featured their work in a special issue (October-November 1941) edited by Nicholas Calas. For the issue, Calas interviewed Breton, recently arrived in New York, who spoke of the need to "read with and look through the eyes of Eros" to offset the war and its destruction. Breton chose two examples of erotic sight "outside of surrealism,"

FIGURE 10

Edward Hopper. *New York Movie*, 1939. Oil on canvas; 81.9 x 101.9 cm. New York, The Museum of Modern Art, Anonymous gift. © 1996 The Museum of Modern Art, New York.

FIGURE 11
Edward Hopper.
Train and Bathers,
1920. Etching printed
in black on white
wove paper; 21.2 x
25 cm. The Art
Institute of Chicago,
Gift of the Print
and Drawing Club
(1944.142).

one of which—Hopper's *New York Movie* (fig. 10)—had just been acquired by The Museum of Modern Art. After seeing this painting at the Modern, Breton was inspired to describe it in this way: "The beautiful young woman, lost in a dream beyond the confounding things happening to others, the heavy mythical column, the three lights of 'New York Movie,' seem charged with a symbolical significance which seeks a way out of the curtained stairway."[28]

Hopper surfaced again in *View* in October 1945, when its associate editor, Parker Tyler, published an article entitled "'Encyclopedism' of American Art."[29] Tyler's piece influenced others, among them the journal's managing editor, John Bernard Myers, who wrote in 1946: "Parker Tyler has taken umbrage at what he considers my 'prejudice' against art by Americans. He agrees with my idea that to speak of 'American art' is parochial and imprecise, but he then surprised me by urging me to really *look* at the work of Edward Hopper, a painter who he believes is first rate."[30] After

a visit to the Rehn Gallery, Myers concluded: "I realized that I hadn't really *seen* Hopper's work, that I simply had lumped him with 'social conscience' artists like Reginald Marsh and Moses Soyer. It gradually dawned on me that Hopper's painting is sophisticated and deeply felt."[31]

When twenty of Hopper's paintings went on display at the Venice Biennale in 1952, several critics compared his art to the early work of Giorgio de Chirico, the Italian metaphysical painter, yet another of the Surrealists' enthusiasms. The two artists shared a penchant for silent, empty spaces. While it is unlikely that Hopper, who had already painted an eerie empty train station by 1908, was ever influenced by looking at the work of de Chirico, it should not surprise us that Stuart Preston reported in the *New York Times*: "Hopper made the deepest impression. Foreigners recognized, and rightly, something authentically American in the pathos of his landscapes, a germ of loneliness that they detect in our literature. 'An American Chirico,' one critic called him."[32] The critic Emily Genauer wrote that she found in Hopper "a haunting mysterious, portentous air which somehow seems related to those early metaphysical paintings of empty, silent city squares done years ago by de Chirico."[33] Hopper himself hated to be classified as an "American Scene" painter.[34] As demonstrated here, his work appealed to a much broader audience, even winning the respect of the Surrealist leader André Breton. Like the art of the Surrealists, with whom Hopper shared his love of French Symbolist poetry, his work demands to be read on many levels, and commensurately rewards the effort.

Hopper and The Art Institute
of Chicago: An Overview

The acquisition of *Nighthawks* crowned a long and constructive relationship between Edward Hopper and The Art Institute of Chicago. Hopper had been etching for only three years when his *Les Poilus* (1917) was shown at the museum in 1918, in an exhibition of etchings organized by the Chicago Society of Etchers. This lone entry depicted three soldiers speaking to a woman in the French countryside during World War I. A year later, Hopper entered four prints into the Society of Etchers' annual show at the Art Institute: *The Bull Fight* (c. 1917), *The Monhegan Boat* (1918), *The Open Window* (1915–18), and *Train and Bathers* (1918; fig. 11). With *A Corner* (1919), which he entered in the organization's show for 1920, he began to present urban scenes with increasing success.

He sent *Night Shadows* in 1921 and *Night in the Park* in 1922 (figs. 4–5). All of these prints except for *Les Poilus* and *The Open Window* were acquired (along with sixteen other prints by Hopper) in 1944 for the Art Institute's permanent collection as a gift of the Print and Drawing Club, which purchased the prints from the New York gallery H. V. Allison and Company.

In 1923 Hopper showed *Evening Wind* (1921; fig. 12) and *Eastside Interior* (1922; fig. 13)

FIGURE 12

Edward Hopper. *Evening Wind*, 1921. Etching printed in black on white wove paper; 17.6 x 21.2 cm. The Art Institute of Chicago, Anonymous Gift Fund (1939.2082).

in the Chicago Society of Etchers exhibition and won the Mr. and Mrs. Frank G. Logan Prize of twenty-five dollars for the latter, which was purchased by the Art Institute. Hopper was so proud of winning the prize that he wrote to the critic Henry McBride, to whom he had given a copy of the print, telling him of the award and quipping: "I don't suppose you believe in the giving of prizes, nor do I except when they are given to me. However now that my fall has been accomplished there is nothing to be done."[35] McBride had prompted the gift when he had singled out Hopper at the American Etchers Salon held in New York at the Brown-Robertson Galleries the previous year: "A little known etcher who stands out in the present exhibition is Edward Hopper, whose 'Evening Wind' and 'Eastside Interior' show positive promise. The 'Evening Wind,' in particular, is full of spirit, composed with a sense of the dramatic possibilities of ordinary materials and is well etched."[36]

For the 1924 Chicago Society of Etchers exhibition, Hopper sent *The Cat Boat* (1922) and *Aux Fortifications* (1923), the last work he made on a French theme. That same year, he first participated in the Art Institute's "Fourth International Water Color Exhibition," showing four works. The next year, Hopper again showed his work at the Art Institute with the Chicago Society of Etchers (*Cow and Rocks* [1918] and *The Railroad* [1922]) as well as in the "International Water Color Exhibition" and in the "Thirty-Eighth Annual Exhibition of Contemporary American Paintings," where he showed an oil, *New York Restaurant* (c. 1922; Muskegon Museum of Art, Muskegon, Mich.).

FIGURE 13

Edward Hopper. *Eastside Interior*, 1922. Etching on paper; 20.0 x 25.3 cm. The Art Institute of Chicago, Mr. and Mrs. Frank G. Logan Prize Fund (1944.144).

From this point on, Hopper exhibited his work frequently at the Art Institute, regularly taking part in the annual exhibitions of paintings and watercolors. He found an important patron in Annie Swan Coburn, who purchased four of his watercolors from the Frank K. M. Rehn Gallery in New York in 1926. Mrs. Coburn gave these to the museum in 1933, a year after they were included in the Art Institute's show of the Coburn Collection.

Two of these watercolors, *Le Terrassier* (*The Roadmender*) and *La Pierreuse* (*The Streetwalker*) (fig. 14), lively caricatures painted in France in 1906, represent his early work in watercolor, most of which was bequeathed to the Whitney Museum by Hopper's widow in 1968. Another work in the Art Institute, *Haskell's House* (*Gloucester Mansion*) of 1923, is an example of Hopper's renewed interest in watercolor as a medium for noncommercial work, which he had abandoned after his French caricatures. He was no doubt drawn to the subject because of its mansard roof, a type of roof he had first admired in his native Nyack. Hopper painted *Interior*, the last of the Art Institute's watercolors, in Santa Fe in 1925; it reveals his embryonic awareness that his new wife, the artist Josephine Nivison, would make an ideal model. Jo noted in the record book that she kept for Edward: "Wife in shirt tail, hair down, foot of oak bed across foreground, bureau top with red powder box-tin, tall."[37]

In 1939, the year after the Art Institute purchased *Compartment C, Car 293*, its first oil by Hopper, he was invited to show a group of twenty-six watercolors in the "Eighteenth International Exhibition of Water Colors, Pastels, Drawings, and Monotypes." Following the acquisition of *Nighthawks* in 1942, the painting became a favorite, launched on its way to the immense popular recognition that it enjoys today. Less than nine years later, the

painting inspired the first of many published poems—by Samuel Yellen.[38] Following the Garrett Prize in 1942, the Art Institute awarded Hopper the Mr. and Mrs. Frank G. Logan Art Institute Medal and a five-hundred-dollar honorarium in 1945 for his painting *Hotel Lobby* (1943; Indianapolis Museum of Art), which was chosen by a jury composed of three New Yorkers: Juliana Force, director of the Whitney Museum, and the artists Reginald Marsh and Raphael Soyer. Finally, in 1950, Hopper traveled to Chicago to accept the School of the Art Institute's honorary doctorate of fine arts. He had become a star in the Art Institute's firmament.

FIGURE 14
Edward Hopper. *La Pierreuse* (*The Streetwalker*), n.d. Watercolor with touches of gouache over graphite on cream wove paper; 30.2 x 23.7 cm. The Art Institute of Chicago, Gift of Annie Swan Cobourn in memory of Olivia Shaler Swan (1933.488).

Notes

GODLEWSKI, "Warm Ashes: The Life and Career of Mary Reynolds," pp. 102–29.

I would like to express my profound gratitude to Marjorie Hubachek Watkins, Mary Reynolds's niece and Brookes Hubachek's daughter, for her unstinting generosity in sharing her fond memories of her Aunt Mary, as well as her gift of the Mary Reynolds Archive and her magnanimous financial support of this issue of *Museum Studies*.

Unless otherwise noted, all correspondence and other original material is from the Mary Reynolds Archive, Ryerson and Burnham Libraries, The Art Institute of Chicago.

1. Marcel Duchamp, "The Mary Reynolds Collection," in Hugh Edwards, ed., *Surrealism and Its Affinities: The Mary Reynolds Collection* (Chicago, 1956), p. 6. A revised edition of this important resource was published in 1973.

2. Calvin Tomkins, *The Bride and the Bachelors: Five Masters of the Avant-Garde* (New York, 1968), p. 53.

3. Letter from Elinor Dayton to Frank B. Hubachek, June 22, 1963.

4. Letter from Frank B. Hubachek to Miss Elizabeth Humes, Aug. 12, 1963.

5. Letter from Elizabeth Hilles to Frank B. Hubachek, Oct. 23, 1963.

6. Jennifer Gough-Cooper and Jacques Caumont, *Ephemerides on and about Marcel Duchamp and Rrose Sélavy, 1887–1968*, in *Marcel Duchamp: Opera*, exh. cat. (Milan, 1993), unpag., entry for June 19, 1924.

7. Janet Flanner, "The Escape of Mrs. Jeffries," part 1, *New Yorker* (May 22, 1943), p. 23.

8. Jimmie Charters (as told to Morrill Cody), "The Barman," in *This Must Be the Place: Memoirs of Montparnasse* (New York, 1989), pp. 100–101.

9. Neil Baldwin, *Man Ray: American Artist* (New York, 1988), p. 227.

10. Jacqueline Bograd Weld, *Peggy: The Wayward Guggenheim* (New York, 1986), p. 53.

11. Ibid., p. 56.

12. Ibid.

13. Man Ray recalled seeing her at the Boeuf one night desperate and drinking heavily. See Man Ray, *Self Portrait* (Boston, 1988), p. 190.

14. Jerrold Seigel, *The Private Worlds of Marcel Duchamp: Desire, Liberation, and the Self* (Berkley, Calif., 1995), p. 193.

15. Virginia M. Dortch, ed., *Peggy Guggenheim and Her Friends* (Milan, 1994), p. 67.

16. Carlton Lake and Linda Ashton, *Henri-Pierre Roché: An Introduction* (Austin, Tex., 1991), p. 64.

17. Pierre Cabanne, *Dialogues with Marcel Duchamp* (London, 1971), p. 68.

18. Dortch (note 15), p. 11.

19. Alice Goldfarb Marquis, *Marcel Duchamp = Eros, C'est la vie: A Biography* (Troy, N.Y., 1981), p. 242.

20. Alastair Duncan and Georges de Bartha, *Art Nouveau and Art Nouveau Bookbinding: French Masterpieces, 1880–1940* (New York, 1989), pp. 19–21. I have consulted this book extensively on the subject of French bookbinding.

21. Dortch (note 15), p. 41.

22. Gough-Cooper and Caumont (note 6), Aug. 10, 1937.

23. See Duchamp (note 1).

24. Letter from Marcel Duchamp to Frank B. Hubachek, Nov. 17, 1953.

25. Duncan and Bartha (note 20), p. 18.

26. Arturo Schwarz, *Man Ray: The Rigour of Imagination* (New York, 1977), p. 62.

27. Man Ray (note 13), p. 190.

28. Anaïs Nin, *The Diary of Anaïs Nin, 1931–34*, ed. Gunther Stuhlmann (New York, 1969), p. 356.

29. Dortch (note 15), p. 10.

30. Gough-Cooper and Caumont (note 6), May 16, 1940.

31. Letter from Marcel Duchamp to Frank B. Hubachek, Apr. 22, 1941.

32. Letter from Mary Reynolds to Frank B. Hubachek, Aug. 7, 1941.

33. Letter from Marcel Duchamp to Frank B. Hubachek, May 29, 1941.

34. Letter from Mary Reynolds to Frank B. Hubachek, Aug. 19, [1940?].

35. Letter from Mary Reynolds to Frank B. Hubachek, Feb. 14, 1942.

36. Letter from Mary Reynolds to Frank B. Hubachek, Nov. 18, 1941.

37. Letter from Mary Reynolds to Frank B. Hubachek, Aug. 7, 1941.

38. Dortch (note 15), p. 44.

39. Letter from Mary Reynolds to Frank B. Hubachek, Nov. 30, 1941.

40. Copy of letter from Jean Hélion to Katharine Kuh, Jan. 29, 1957.

41. Letter from Mary Reynolds to Frank B. Hubachek, Jan. 8, 1941.

42. Letter from Mary Reynolds to Frank B. Hubachek, Nov. 18, 1941.

43. Letter from Kay Boyle to Frank B. Hubachek, Mar. 2, 1942.

44. Letter from Peggy Guggenheim to Frank B. Hubachek, Jan. 19, 1942.

45. Letter from Frank B. Hubachek to M. L. Boynton, May 13, 1963. Hubachek also wrote in this letter that Reynolds's home "became the gathering point and the dispatching point for the spy poste. It was also a Paris station for the escape route. There was a continuous procession of individuals, microfilm, used parachutes, and so on."

46. This account of Reynolds's escape relies principally on two sources: a file in Record Group 226, Records of the Office of Strategic Services, National Archives (the Mary Reynolds Archive at the Art Institute has a copy of the file); and the article by Janet Flanner (see note 7), which appeared in the *New Yorker* in the issues of May 22, May 29, and June 5, 1943.

47. National Archives, Files of the Office of Strategic Services, secret document, Jan. 8, 1943.

48. Man Ray (note 13), p. 258.

49. Letter from Frank B. Hubachek to Marcel Duchamp, Jan. 4, 1943.

50. Letter from Frank B. Hubachek to Pan-American Airways, Oct. 1, 1942.

51. Cable from Mary Reynolds to Frank B. Hubachek, Dec. 14, 1942.

52. Gough-Cooper and Caumont (note 6), Oct. 9, 1943.

53. Man Ray (note 13), p. 210.

54. National Archives, Files of the Office of Strategic Services, Interviewer's Report, July 25, 1944.

55. Letter from Alexander Calder to Frank B. Hubachek, July 13, 1955.

56. Gough-Cooper and Caumont (note 6), Jan. 8, 1947.

57. Letter from Mary Reynolds to Charles Henri Ford, Sept. 27, 1945, Charles Henri Ford Papers, Beinecke Library, Yale University.

58. Letter from Mary Reynolds to Charles Henri Ford, Mar. 3, 1946, Charles Henri Ford Papers, Beinecke Library, Yale University.

59. Postcard from Mary Reynolds to Janet Flanner, June 30, 1949, Janet Flanner Papers, Manuscript Division, Library of Congress.

60. Gough-Cooper and Caumont (note 6), June 28, 1950.

61. Ibid., July 17, 1950.

62. Ibid., Sept. 23, 1950.

63. Ibid., Sept. 26, 1950.

64. Letter from Jean Cocteau to Marcel Duchamp, Feb. 2, 1957 ("Mon très cher Marcel—Il est rare que la mort laisse des cendres chauds. Grâce à toi c'es[t] ce qui se passe pour Mary. Je te félicite et je t'embrasse"). English translation by Duchamp.

65. Letter from Janet Flanner to Frank B. Hubachek, June 7, 1957.

66. Gough-Cooper and Caumont (note 6), Nov. 26, 1934.

67. Marcel Duchamp, "Katharine Kuh Mss" (unpub. ms.), Bienecke Library, Yale University.

68. Arturo Schwarz, ed., *The Complete Works of Marcel Duchamp*, 2nd rev. ed. (New York, 1970), no. 307.

HOFMANN, "Documents of Dada and Surrealism: Dada and Surrealist Journals in the Mary Reynolds Collection," pp. 130-49.

Original editions of journals discussed in this essay, with the exception of *Rongwrong, New York Dada, Littérature, Le Cannibale,* and *Documents,* can be found in the Mary Reynolds Collection at The Art Institute of Chicago.

1. For further information on Dada and Surrealist journals, see Dawn Ades, *Dada and Surrealism Reviewed,* exh. cat. (London 1978); and for more on Dada publications, see University of Iowa Museum of Art, *Dada Artifacts,* exh. cat. (Iowa City, Iowa, 1978).

2. In founding the Cabaret Voltaire, Ball made an arrangement with Herr Ephraim, the owner of what was then known as Meierei Bar. Ball promised the bar's owner that if he were allowed to use the space as a cabaret, he would be able to increase the establishment's sales of beer and food. See Hans Richter, *Dada: Art and Anti-Art* (London, 1966), p. 13.

3. Ibid., p. 16.

4. Ibid., p. 12.

5. See Tristan Tzara, "Lecture on Dada," repr. and trans. in *The Dada Painters and Poets: An Anthology,* ed. Robert Motherwell (Cambridge, Mass., 1989), p. 250.

6. Marcel Janco, "Dada at Two Speeds," trans. in Lucy R. Lippard, *Dadas on Art* (Englewood Cliffs, N.J., 1971), p. 36.

7. This publication included the first appearance of the term "dada" in print.

8. Hugo Ball, "Lorsque je fondis le Cabaret Voltaire," *Cabaret Voltaire* (1916), unpag.; repr. and trans. in Motherwell (note 5), p. xxv.

9. Richard Huelsenbeck, *En Avant Dada: Eine Geschichte des Dadaismus* repr. and trans. by Ralph Manheim in Motherwell (note 5), p. 29.

10. Richter (note 2), p. 33.

11. Ibid., p. 226.

12. Repr. and trans. in Motherwell (note 5), pp. 107-08.

13. Maria Lluïsa Borràs, *Picabia* (New York, 1985), p. 199.

14. Richter (note 2), p. 81.

15. *291,* named after Alfred Steiglitz's progressive New York gallery that made its mark as one of the U.S. centers for the avant-garde, was the city's first journal devoted to the work of modern artists. Published from March 1915 to February 1916, the nine issues of *291* were known for presenting the most experimental works in art and design. Some artists featured in *291* include Francis Picabia, Georges Braque, Pablo Picasso, and John Marin.

16. Motherwell (note 5), p. 263.

17. Ibid.

18. Arturo Schwarz, *The Complete Works of Marcel Duchamp* (New York, 1969), p. 584.

19. See the entry on *The Blind Man* 2 in *Dada Artifacts* (note 1), p. 72.

20. In addition to the regular run of this issue, fifty special-edition copies were printed on imitation Japan paper. These copies were numbered and signed by Beatrice Wood.

21. *Dada Artifacts* (note 1), p. 72.

22. *New York Dada* (Apr. 1921), p. 2.

23. *Littérature* was founded by Aragon, Breton, and Philippe Soupault. The twelve issues of *Littérature* were published in Paris between March 1919 and April 1921. A rather eclectic journal, *Littérature* features writing by figures such as poets Guillaume Apollinaire and Paul Valéry along with Arensberg, Arp, and Eluard.

24. Some of the other Dada-related journals published in Paris during this time include *Proverbe,* edited by Eluard; *Sic,* edited by Pierre Albert Birot; and *Nord-Sud,* edited by Pierre Reverdy.

25. Lucy R. Lippard, ed., *Surrealists on Art* (Englewood Cliffs, N.J., 1970), p. 184.

26. At one point, Breton had even contemplated merging *Littérature* with *Dada.*

27. André Breton, "Lâchey tout," in *Littérature,* n.s., no. 2 (Apr. 1922), unpag.; repr. and trans. in Ades (note 1), p. 166.

28. Quoted in Motherwell (note 5), pp. 188-90.

29. The name "Surrealism" was given to the movement by André Breton and Philippe Soupault in homage to the French writer Guillaume Apollinaire, who first used the word in 1917 to describe his play *Les Mamelles de Tirésias.*

30. André Breton, *Manifestoes of Surrealism,* trans. Richard Seaver and Helen R. Lane (Ann Arbor, Mich., 1969), p. 26.

31. The circulation of *La Révolution surréaliste* was approximately one thousand.

32. Antonin Artaud, "Adresse au Pape," in *La Révolution surréaliste* 3 (Apr. 1925), p.16; repr. and trans. in Patrick Walberg, *Surrealism* (New York, 1965), p. 59.

33. Ted Gott, "Lips of Coral: Sex and Violence in Surrealism," in *Surrealism: Revolution by Night,* exh. cat. (Canberra, 1993), pp. 136-38.

34. The title *Minotaure* was suggested by Bataille and Masson and reflects the Surrealists' interest in myths and their interpretations.

35. For a more in-depth study of *Minotaure,* see Geneva, Musée d'art et d'histoire, *Focus on Minotaure,* exh. cat. (1987).

TAYLOR, "Hans Bellmer in The Art Institute of Chicago: The Wandering Libido and the Hysterical Body," pp. 150-65.

1. Hans Bellmer, quoted in Peter Webb and Robert Short, *Hans Bellmer* (New York, 1985), p. 29. The foregrounding of these three catalyzing incidents by Webb and others ignores two factors that seem most relevant to Bellmer's invention of the doll from a psychological point of view. The 1931 shipment of toys came as his mother broke up housekeeping in Gleiwitz, where Bellmer's father, Hans senior, had suffered a cerebral hemorrhage and retired from his job as an engineer. Although he recovered from this stroke, his right arm was still paralyzed when the family relocated to Berlin. The following year, the artist's young wife, Margarete Schnell Bellmer, was diagnosed with tuberculosis. Threatened with loss, Bellmer fashioned a transitional object in the form of a life-size doll—just as a child during weaning, according to the object-relations theories of D. W. Winnicott, may attach to a favorite object qualities of the comforting relationship he enjoys with the mother he is gradually losing; see Winnicott, "Transitional Objects and Transitional Phenomena," *International Journal of Psychoanalysis* 34 (1953), pp. 89-97. I owe the information about Hans senior's paralysis, his first name, as well as the birth name of the artist's wife to Ursula Naguschewski, who kindly responded to my inquiries in her letters of July 18, 1994, and February 2, 1996, from Ispringen, Germany. (It was Naguschewski, enrolled at the Sorbonne in 1934, who first brought Bellmer's photographs to the attention of André Breton in Paris.) I am also indebted to Thomas Bellmer, the artist's nephew, for information about the Bellmer family, which he has shared with me in correspondence and various telephone and personal interviews in Kearney, N.J., from October 1994 to the present.

2. Hans Bellmer, "Memories of the Doll Theme," trans. Peter Chametzky, Susan Felleman, and Jochen Schindler, *Sulfur* 26 (Spring 1990), pp. 29-30; subsequent quotations in this paragraph are from pp. 31-33. This is the only published English translation of the entire essay, of which an excerpt can also be found in Lucy R. Lippard, ed., *Surrealists on Art* (Englewood Cliffs, N.J., 1970), pp. 63-66. Both the French and German versions of Bellmer's essay are available in the special 1975 number of *Obliques* devoted to the artist, pp. 58-65.

3. The Art Institute owns three portraits by Bellmer: a small profile head of artist Max Ernst in pencil and white gouache from 1940 (1980.83); a larger, three-quarter-length ink sketch of artist Wifredo Lam on composition board from 1964 (1967.143); and the double-sided portrait of writer Unica Zürn illustrated in figs. 13 and 14.

4. According to Webb and Short (note 1), p. 24, the artist spent many hours poring over works by Albrecht Altdorfer, Niklaus Manuel Deutsch, Urs Graf, and Hans Baldung Grien. Perhaps these northern draftsmen were also represented in his personal collection of prints and drawings; Unica Zürn reported that when the artist departed Germany in haste in 1938, he "left his residence in Karlshorst full of books, pictures, and an expensive graphics collection" (see "Die Begegnung mit Hans Bellmer," in *Unica Zürn: Gesamtausgabe,* vol. 5 [Berlin, 1989], p. 138 [my translation]).

5. In 1953 Bellmer's Berlin dealer, Rudolf Springer, reissued *The Doll,* using

leftover sheets from the first 1934 edition. Webb and Short (note 1), p. 278, stated that "it is not known how many of each [German] edition were made, but the total is less than fifty."

6. Bellmer (note 2), p. 33.

7. "Bellmer manipulates the doll," in Hal Foster's words, "as if to ascertain the signs of difference and the mechanics of birth" (see Foster, *Compulsive Beauty* [Cambridge, Mass., 1993], p. 106). Foster, along with René R. Held, *L'Oeil du psychanalyste: Surréalisme et surréalité* (Paris, 1973), p. 311, compares Bellmer with Freud's famous patient Little Hans, whose curiosity about his mother's pregnancy is the subject of Freud's "Analysis of a Phobia in a Five-Year-Old Boy" (1909), in *The Standard Edition of the Complete Psychological Works of Sigmund Freud*, vol. 10, trans. James Strachey (London, 1955), pp. 1–147. Unaware that the elder Bellmer's first name was also Hans, Foster and Held did not fully realize the uncanny aptness of their reference.

8. Bellmer discovered these dolls with his friend Lotte Pritzel, herself a doll-maker as well as a costume designer. These particular specimens are no longer extant but are reproduced in Staatlichen Museen Preussischer Kulturbesitz, *Der Mensch um 1500: Werke aus Kirchen und Kunstkammern*, exh. cat. (West Berlin, 1977), p. 171. Webb and Short (note 1), p. 59, included an illustration of a comparable figure.

9. If child abuse seems to be the implied subject of this image and others in Bellmer's oeuvre, additional levels of interpretation have also been put forward. Notably, Therese Lichtenstein, in "The Psychological and Political Implications of Hans Bellmer's Dolls in the Cultural and Social Context of Germany and France in the 1930s" (Ph.D. diss., City University of New York, 1991), saw the mutated bodies of the dolls opposing the whole and healthy Aryan bodies fantasized in Nazi propaganda, while Sidra Stich, in University Art Museum, University of California at Berkeley, *Anxious Visions: Surrealist Art*, exh. cat. (New York, 1990), p. 54, contended that their corporeal fragmentation reflects the social reality of ubiquitous amputees with their prosthetic limbs, seen throughout Europe in the wake of World War I. Those amputees, however, as Maria Tatar reminded us in *Lustmord: Sexual Murder in Weimar Germany* (Princeton, N.J., 1995), "testified to the brutalization of *men's* bodies in the theaters of war" (p. 12, my emphasis), whereas Bellmer's depicted victims are female. Tatar pondered the possibility that the many representations of sex murders in German art, literature, and film between the wars were in part a kind of fantasized revenge on women, who had escaped the damaging carnal effects of the military experience.

10. Webb and Short (note 1), p. 70.

11. Lichtenstein (note 9), p. 74.

12. Webb and Short (note 1), p. 62. See *Cahiers d'art* 11 (1936), unpag., where the photograph of the doll tied on a staircase (fig. 6) is reproduced along with an excerpt from "Memories of the Doll Theme"; and *Minotaure* 8 (1936) and 10 (1937), where works by Bellmer accompany an article by E. Tériade on "La Peinture surréaliste" or are grouped together with works by Surrealists of various nationalities.

13. For the poems, see Paul Eluard, *Oeuvres complètes*, vol. 1, ed. Marcelle Dumas and Lucien Scheler (Paris, 1968), pp. 1007–10; or Centre Georges Pompidou, *Paul Eluard et ses amis peintres*, exh. cat. (Paris, 1983), pp. 80–81. For the French verses and German translations juxtaposed with reproductions of Bellmer's photographs, see also *Obliques* (note 2), pp. 98–104.

14. As a result of the declaration of war on September 3, 1939, Bellmer was interned as a foreign national at the Camp des Milles in Aix-en-Provence. Max Ernst arrived at the same camp in October, hence Bellmer's portrait drawing of him mentioned in note 3 above. Pressed into the Service Corps of Foreign Nationals in April 1940, Bellmer was demobilized in June of that year. See Webb and Short (note 1), pp. 113–27; and Jacques Grandjonc, ed., *Les Camps en Provence: Exil, internement, déportation, 1933–1944* (Aix-en-Provence, 1984).

15. During the decade that elapsed between the conception of the book and its publication, Bellmer was briefly married to an Alsatian woman from Colmar; the dedication of *Les Jeux de la poupée*, "à Doriane," refers to one of his twin daughters, born in 1943, whom he did not see again until 1967.

16. Both French and German versions of Bellmer's essay can be found in *Obliques* (note 2), pp. 82–91; the original handwritten French text, complete with editorial changes but missing the last few paragraphs of the published essay, is reproduced in idem, pp. 45–55. Webb and Short (note 1), pp. 62, 66–67,

included several brief portions of the text in English, as did Henry Okun, "The Surrealist Object" (Ph.D. diss., New York University, 1981), pp. 438–40, 442–43. The full English translation appears in Sue Taylor, "The Anatomy of Anxiety: A Psychoanalytic Approach to the Work of Hans Bellmer" (Ph.D. diss., University of Chicago, in progress).

17. Webb and Short (note 1), p. 100, and *Obliques* (note 2), p.187.

18. Webb and Short (note 1), p. 102.

19. Bellmer (note 16, my translation). The quotation in the following paragraph is also from this work.

20. Paul Schilder became a professor of psychiatry at the University of Vienna and, after his emigration to New York, a research professor of clinical psychiatry at New York University College of Medicine and Clinical Director at Bellevue Psychiatric Hospital. His work on body image became widely known even beyond psychiatric circles: Ernst Gombrich invoked Schilder's researches in his famous lecture on "Psychoanalysis and the History of Art" (1953) in his *Meditations on a Hobby Horse and Other Essays on the Theory of Art* (New York, 1963), p. 34.

21. Sigmund Freud, *Introductory Lectures on Psychoanalysis* (1916–17), in *The Standard Edition* (note 7), vol. 16 (1963), p. 345.

22. From a psychobiographical point of view, it is important to note that Bellmer's development of the doll coincided with the diagnosis of his wife's tuberculosis in the early 1930s (see note 1 above). In an interview with Peter Webb (*The Erotic Arts* [Boston, 1975]), Bellmer brought his invention of the dolls into association with his dejection in the 1930s: "Obviously, there was a convulsive flavor to them because they reflected my anxiety and unhappiness" (p. 369). One must look to other factors as well—including of course the menacing political climate in Germany—for the artist's stated unhappiness, but his agonized marital relations should be considered in light of his insistence that the fetishistic dolls "became an erotic liberation for [him]" (idem).

23. Lichtenstein (note 9), pp. 175, 184–86. See Paul Schilder, *The Image and Appearance of the Human Body: Studies in the Constructive Energies of the Psyche* (New York, 1950).

24. Paul Schilder, "Vita and Bibliography of Paul Schilder," *Journal of Criminal Psychopathology* 2 (1940), p. 222; and idem, *The Image and Appearance of the Human Body* (note 23), p. 182.

25. Bellmer in fact derived the organization of his *Anatomie de l'image* (see note 32 below) from Schilder's *Image and Appearance of the Human Body*: Bellmer's three chapters, "Les Images du moi," "L'Anatomie de l'amour," and "Le Monde extérieur," correspond sequentially and thematically to Schilder's three headings, "The Physiological Basis of the Body-Image," "The Libidinous Structure of the Body-Image," and "The Sociology of the Body-Image," respectively. In terms of sources, one wonders too whether Bellmer's "physical unconscious" was in any way a response to Walter Benjamin's notion of an "optical unconscious," introduced in the latter's "Small History of Photography" in 1931. "It is through photography," wrote Benjamin, "that we first discover the existence of this optical unconscious [of the different stages of a bodily movement, as documented, for example, by Eadweard Muybridge], just as we discover the instinctual unconscious through psychoanalysis" (quoted in Rosalind Krauss, *The Optical Unconscious* [Cambridge, Mass., 1993], p. 178).

26. Perhaps Bellmer's fascination with this research was motivated or intensified by his own father's semiparalysis in 1931 (see note 1 above).

27. Schilder (note 23), pp. 67, 206.

28. These drawings, *Untitled* and *Hands of a Budding Minx* (both 1934), and several others are reproduced in Michel Butor, "La Multiplication des mains," *Obliques* (note 2), pp. 13–17.

29. Reproduced in Editions Denoël, *Les Dessins de Hans Bellmer* (Paris, 1966), pp. 49–50.

30. Reproduced in Centre Georges Pompidou, *Hans Bellmer Photographe*, exh. cat. (Paris, 1983), pp. 114–15; and in Rosalind Krauss and Jane Livingston, *L'Amour fou: Photography and Surrealism*, exh. cat. (Washington, D.C., 1985), pp. 52–53.

31. Schilder (note 23), p. 54 n. 1. The following citation is also from this source. Schilder had published a study on this specific phenomenon with E. Klein

in "Japanese Illusion and Postural Model of the Body," *Journal of Nervous and Mental Disorders* 70 (1929), pp. 241–63.

32. Hans Bellmer, *Petite Anatomie de l'inconscient physique ou l' anatomie de l'image* (Paris, 1957). The book is unpaginated, but the relevant passage occurs toward the beginning of the first chapter, "Les Images du moi." The translations that follow are mine.

33. Lichtenstein (note 9), pp. 175–81, analyzed how "Bellmer turns Lombroso's nineteenth-century pseudoscientific theory into a phantastic poetic vision." According to Webb and Short (note 1), p. 275 n. 22, Bellmer owned a copy of Lombroso's *L'Homme criminel* (Paris, 1887) and of Lombroso and G. Ferrero, *La Femme criminelle et la prostituée* (Paris, 1896).

34. Louis Aragon and André Breton, "La Cinquantenaire de l'hystérie (1878–1928)," *La Révolution surréaliste* 11 (Mar. 15, 1928), pp. 20–22. This journal is among the many Surrealist publications preserved in the Mary Reynolds Collection at The Art Institute of Chicago.

35. For a social analysis and modern history of the concept of this elusive disease, which "does not even exist at present in the United States as an officially recognized diagnostic category," see Martha Noel Evans, *Fits and Starts: A Genealogy of Hysteria in Modern France* (Ithaca, N.Y., 1991), p. 6. A more general account can be found in Ilza Veith, *Hysteria: The History of a Disease* (Chicago, 1965).

36. Lichtenstein (note 9), p. 178.

37. See, for example, Centre Georges Pompidou (note 30), pp. 48, 68, 71.

38. For various illustrations of the *arc en cercle*, see Georges Didi-Huberman, *Invention de l'hystérie: Charcot et l'iconographie photographique de la Salpêtrière* (Paris, 1982), fig. 106; Evans (note 35), p. 25; and Veith (note 35), fig. 8. Charcot's periodization of attacks—the prodrome, clonic phase, period of "clownism," *grandes attitudes*, and resolution—was well known to the Surrealists. See especially Robert J. Belton, "An Hysterical Interlude," in *The Beribboned Bomb: The Image of Woman in Male Surrealist Art* (Calgary, 1995), pp. 240–49.

39. Jules Claretie, *Les Amours d'un interne* (Paris, 1902), p. 174; quoted in Rodolphe Rapetti, "From Anguish to Ecstasy: Symbolism and the Study of Hysteria," in Montreal Museum of Fine Arts, *Lost Paradise: Symbolist Europe*, exh. cat. (Montreal, 1995), p. 233 (his translation).

40. See Katharina Gerstenberger, "'And This Madness Is My Only Strength': The Lifewriting of Unica Zürn," *a/b: Auto/Biography Studies* 6, 1 (Spring 1991), pp. 40–53, for an account of Zürn's work in light of "the complex relationship of women's autobiographical writings and discourses on illness." I am indebted to Dr. Gerstenberger for sharing her work on Zürn with me.

41. Unica Zürn, "Remarques d'un observateur," in *Gesamtausgabe* (note 4), p. 163 (my translation).

42. Ibid. Katharina Gerstenberger cited a similar passage in Zürn's *Notizen zur letzten (?) Krise* (1966), in chap. 4 of "Writing Herself into the Center: Centrality and Marginality in the Autobiographical Writing of Nahida Lazarus, Adelheid Popp, and Unica Zürn" (Ph.D. diss., Cornell University, 1993), p. 163: "In this posture (in the moment of rapture)," wrote Zürn, "the woman resembles one of those astonishing cephalopods such as Bellmer often drew: the woman consisting of just head and abdomen, her arms replaced by legs. Which is to say: she has no arms. This patient even has the protruding tongue of Bellmer's cephalopods, which has something outrageous about it." The translation is Malcolm Green's in the first English edition of Zürn's "Notes on Her Last (?) Crisis" in *The Man of Jasmine and Other Texts* (London, 1994), p. 144.

43. See Webb and Short (note 1), pls. xxviii, xxix, and figs. 215, 246–49.

44. A copy of *Le Surréalisme, même* 4 (Spring 1958) is preserved in the Mary Reynolds Collection. The French caption to Bellmer's cover photograph reads "Tenir à frais."

45. Zürn, "Remarques d'un observateur" (note 41), p. 163 (my translation).

KUNNY, "Leonora Carrington's Mexican Vision," pp. 166–79.

I would like to thank Mia Kim, Marek Keller, Gunther Gerzso and his wife Gene, and, last but not least, Juan Soriano for the time they took to speak with me about Leonora Carrington. Their remembrances of her and the Mexican art world from the 1940s to the 1960s are invaluable. In my research for this article, I have drawn on the entry by Dawn Ades on Carrington's *Juan Soriano de Lacandón* that will appear in the book *Surrealist Art: The Lindy and Edwin Bergman Collection at The Art Institute of Chicago* to be published in 1997.

1. Maurice Nadeau, *The History of Surrealism*, trans. Richard Howard (New York, 1965), p. 199.

2. Monterrey, Museo de Arte Contemporáneo, *Leonora Carrington: Una Retrospectiva*, exh. cat. (1994), p. 145. Carrington met Ernst through Ursula Goldfinger, a classmate at Ozenfant's school, who arranged a dinner party for the two to meet. Carrington and Ernst immediately sensed mutual creative interests, and an emotional bond developed shortly thereafter.

3. On a trip they made to Cornwall, Ernst introduced Carrington to his friends Nusch and Paul Eluard, Man Ray, Lee Miller, and Roland Penrose. In the next couple of years this group of painters and poets visited Ernst and Carrington at their home in southern France. See Monterrey (note 2), p. 145.

Collaborative projects between painters and writers resulted in magnificent illustrated texts. At the time Carrington and Ernst met, he was working on illustrations for Alfred Jarry's play *Ubu Roi*. In 1938 Carrington published the short story "The House of Fear," with a preface and collage illustrations by Ernst.

4. Monterrey (note 2), p. 25.

5. American photographers Edward Weston and Tina Modotti worked in Mexico in the 1920s, and Paul Strand worked there in the 1930s. European Surrealist writers such as Antonin Artaud visited Mexico and returned to Europe with glowing reports about the country, as well as the work of its artists. Surrealist painters Alice Rahon and Wolfgang Paalen moved there in 1939. Paalen, André Breton, and the Peruvian poet Cesar Moro coorganized the International Surrealist exhibition in Mexico City in 1940.

6. Serge Fauchereau, "Surrealism in Mexico," *Artforum* 25 (Sept. 1986), p. 90.

7. Hayden Herrera, *Frida: A Biography of Frida Kahlo* (New York, 1983), p. 256.

8. Author's conversation with Gunther Gerzso, Mexico City, April 1996.

9. Helen Byatt, "Introduction," in Leonora Carrington, *The Hearing Trumpet* (London, 1991), p. 2.

10. *The Temptation of Saint Anthony* was created for an invitational contest held in 1945–46 to select a painting on this theme for the Hollywood film "Bel-Ami," starring George Sanders, Angela Lansbury, and John Carradine. Carrington was one of two women invited to compete with the likes of Chicago's Ivan Albright and the Surrealists Salvador Dali, Paul Delvaux, and Max Ernst, who was now living in the United States. The other female entrant was Dorothea Tanning, Ernst's current wife. To be asked to participate in such a competition indicates the degree to which Carrington had established, by this time, an international reputation for her Surrealist compositions. Ernst's composition won; Albright's placed second. See Harriet Janis, "Artists in Competition" *Arts and Architecture* (Apr. 1946), pp. 30–33, 52–55.

11. Janet Kaplan, *Unexpected Journeys: The Art and Life of Remedios Varo* (New York, 1988), p. 87. Rivera's use of terms such as "colonizer" and "false artists" indicates that he believed that the only valid art was one made by Mexican artists for the Mexican people.

12. See Herrera (note 7), pp. 241–66.

13. Kaplan (note 11), pp. 140–41. In 1959 Remedios Varo accepted a commission to paint a mural, which she never completed, for the Cancer Pavilion in Mexico City.

14. Author's conversation with Juan Soriano, Mexico City, April 1996. Soriano said he was not interested in the Surrealist style of painting, nor in the movement's theories; it was, rather, the personalities of some of the Surrealists that attracted him.

15. Virginia Stewart, *Forty-Five Contemporary Mexican Artists* (Stanford, Calif., 1951), p. 151.

16. Author's conversation with Juan Soriano (note 14). Soriano noted that "Poesía en Voz Alta" produced classic as well as new plays.

17. Whitney Chadwick, "El Mundo Mágico: Leonora Carrington's Enchanted Garden," in San Francisco, The Mexican Museum, *Leonora Carrington: The Mexican Years*, exh. cat. (Seattle, 1991), p. 28.

18. Kaplan (note 11), p. 139. Varo inscribed the card, "Juanito, many greetings, don't let it bother you that this drawing is so bad, because it is a document of

great historic value. You are dealing with the only portrait that exists of baron Angelo Milfastos when he was a child and began to cut off the heads of his aunts. He later died on the gallows, but that was a great injustice and a judicial error. He was by no means a criminal but the inventor of a magnificent new contraption for sharpening knives; in cutting off heads he only set out to test the apparatus." The inscription refers to Juan Soriano's family history—he has often boasted of his thirteen aunts.

19. For Maya prototypes, see Linda Schele and Mary Ellen Miller, *The Blood of Kings: Dynasty and Ritual in Maya Art*, exh. cat. (Forth Worth, Tex., 1986), pp. 66–69. Attapulgite clay was used by Maya artists to make a blue pigment; because the blue color is permanent, it remains visible on Maya art today. Artists painted ceramic figurines, such as the Jaina pieces, using the "Maya blue." It was also used in mural paintings, the most spectacular examples of which are at Bonampak in southern Mexico.

20. Hammocks are the common sleeping aparatus of the Lacandón Indians of Chiapas; they are also a ubiquitous item of trade today, frequently sold to tourists. Carrington's inclusion of the hammock in the painting seems to have been intended as a subtle bit of humor.

21. Linda Schele and David Freidel, *A Forest of Kings: The Untold Story of the Ancient Maya* (New York, 1990), p. 61.

22. See Mary Ellen Miller, "The Image of People and Nature in Classic Maya Art and Architecture," in Richard F. Townsend, ed., *The Ancient Americas: Art from Sacred Landscapes*, exh. cat. (Chicago and Munich, 1992), pp. 164–68.

23. The few instances where Mexico becomes the subject of her art include a 1947 painting, *Saint John's Mule* (private collection), and a short story, "The History of Mole," from around the same time.

24. The following is a partial list of Carrington's exhibition activity in Mexico City in the fifties: solo exhibitions at the Galería Clardecor in 1950 and at the Galería Antonio Souza in 1957; and group exhibitions at the Galería Diana in 1955 and at the Salon Frida Kahlo, Galería de Arte Contemporaneo, in 1956.

25. Dawn Ades, *Art In Latin America: The Modern Era, 1820–1980*, exh. cat. (New Haven, Conn., 1989), pp. 198–201.

26. Chadwick (note 17), p. 26.

27. Dorie Reents-Budet, *Painting the Maya Universe: Royal Ceramics of the Classic Period*, exh. cat. (Durham, N.C., 1994), pp. 48–49.

LEVIN, "Edward Hopper's *Nighthawks*, Surrealism, and the War," pp. 180–95.

This essay is for Hedy Davenport.

1. I am grateful to the University of Tennessee at Chattanooga, where I held the American National Bank Chair of Excellence in the Humanities for 1995–96, during the course of writing this article.

2. Jo Hopper, Diary, Dec. 15, 1936. For a discussion of Jo Hopper's diaries, see Gail Levin, *Edward Hopper: An Intimate Biography* (New York, 1995), pp. xv–xiv, 248.

3. Edward Hopper, "Notes on Painting," in Alfred H. Barr, Jr., *Edward Hopper: Retrospective Exhibition*, exh. cat. (New York, 1933), p. 17.

4. André Breton, *Surrealism and Painting* (New York, 1972), p. 4, cites "Lautréamont, Rimbaud, and Mallarmé" as "the first to endow the human mind with a quality that it had entirely lacked." See also Gail Levin, "Edward Hopper: Francophile," *Arts Magazine* 53, 10 (June 1979), pp. 114–21.

5. André Breton, in "The First Surrealist Manifesto," quoted in Lucy R. Lippard, ed., *Surrealists on Art* (Englewood Cliffs, N.J., 1970), p. 10.

6. Max Eastman, "Exploring the Soul and Healing the Body," *Everybody's Magazine* 32 (June 1915), pp. 741–50.

7. Their ideas remained current and by 1933, in the sixth chapter ("Freud and Jung—Contrasts") of a collection of essays addressed to a general public, Jung himself sought to explain the difference between their views. See C. G. Jung, *Modern Man in Search of a Soul* (New York, 1933), pp. 132–42.

8. Guy Pène du Bois, Diary, Nov. 30, 1918, Guy Pène du Bois Papers, Archives of American Art.

9. See Levin (note 2), p. 277.

10. Jung (note 7), p. 18.

11. Gordon Onslow Ford, quoted in Martica Sawin, *Surrealism in Exile and the Beginning of the New York School* (Cambridge, Mass., 1995), p. 165. See also Dickran Tashjian, *A Boatload of Madmen: Surrealism and the American Avant-Garde, 1920–1950* (New York, 1995).

12. For a discussion of the effect of World War II on the Hoppers, as well as other information related to the painting of *Nighthawks*, see Levin (note 2), esp. pp. 348–57.

13. Letter from Edward Hopper to Guy Pène du Bois, Aug. 11, 1940. The quotation that follows is also drawn from this letter.

14. Jo Hopper, Diary, Jan. 24, 1940.

15. Joan Miró, quoted in James Johnson Sweeney, *Joan Miró* (New York, 1941), p. 13.

16. Letter from Jo Hopper to Marion Hopper, Dec. 17, 1941.

17. Letter from Jo Hopper to Marion Hopper, Jan. 22, 1942.

18. For a discussion of the Surrealists' response to the horrors of World War I, see Sidra Stich, ed., *Anxious Visions: Surrealist Art*, exh. cat. (New York, 1990).

19. Jo Hopper, Diary, Mar. 17, 1942.

20. Jo Hopper, Diary, May 11, 1942.

21. The Art Institute of Chicago, *The Fifty-Third Annual Exhibition of American Paintings and Sculpture*, exh. cat. (1942), unpag. The exhibition was held at the Art Institute from Oct. 29 to Dec. 10, 1942; Hopper was represented only by *Nighthawks*, which is no. 132 in the catalogue.

22. "The Twenty-Second International Exhibition of Water Colors" was held at the Art Institute from May 13 to Aug. 22, 1943.

23. Katharine Kuh, public relations counsel, "Water Color Jury to Meet," news release from The Art Institute of Chicago, Apr. 6, 1943.

24. Eleanor Jewett, "Fine Paintings in 22nd Water Color Exhibit," *Chicago Tribune*, May 16, 1943.

25. Frederick A. Sweet, "Foreword," in The Art Institute of Chicago, *The Twenty-Second International Exhibition of Water Colors*, exh. cat. (1943), unpag. The quotations that follow in this paragraph and the next are also drawn from this source.

26. Frederick A. Sweet, "Foreword," in The Art Institute of Chicago, *The Fifty-Fourth Annual Exhibition of American Paintings and Sculpture*, exh. cat. (1943), unpag. Sweet's comments in this paragraph and the next are drawn from this source.

27. C. J. Bulliet, "Artless Comment on the Seven Arts," *Chicago Daily News*, Oct. 30, 1943, p. 7.

28. Nicolas Calas, "Interview with André Breton," *View* 1, 7–8 (Oct.-Nov. 1941), p. 1.

29. Parker Tyler, "'Encyclopedism' of American Art," *View* 5, 3 (Oct. 1945), p. 17.

30. John Bernard Myers, *Tracking the Marvelous: A Life in the New York Art World* (New York, 1983), p. 70.

31. Ibid.

32. Stuart Preston, "Art Survey by Nations," *New York Times*, July 20, 1952, sec. 10, p. 2.

33. Emily Genauer, "National Pavilions in Big Venice Biennial Exhibit Offer Surprises," *New York Herald Tribune*, June 29, 1952, sec. 4, p. 8.

34. See Gail Levin, "Edward Hopper and the Democratic Tradition," in Alfred Hornung et al., *Democracy and the Arts in the United States* (Munich, 1996), pp. 85–87.

35. Letter from Edward Hopper to Henry McBride, Feb. 19, 1923.

36. Henry McBride, "Art News and Reviews—Public," *New York Herald*, Feb. 26, 1922, sec. 3, p. 5.

37. See Gail Levin, *Edward Hopper: A Catalogue Raisonné* (New York, 1995), vol. 2, p. 87.

38. See Gail Levin, ed., *The Poetry of Solitude: A Tribute to Edward Hopper* (New York, 1995), p. 32, for this and other poems the painting has inspired.